The Campus History Series

BETHANY COLLEGE

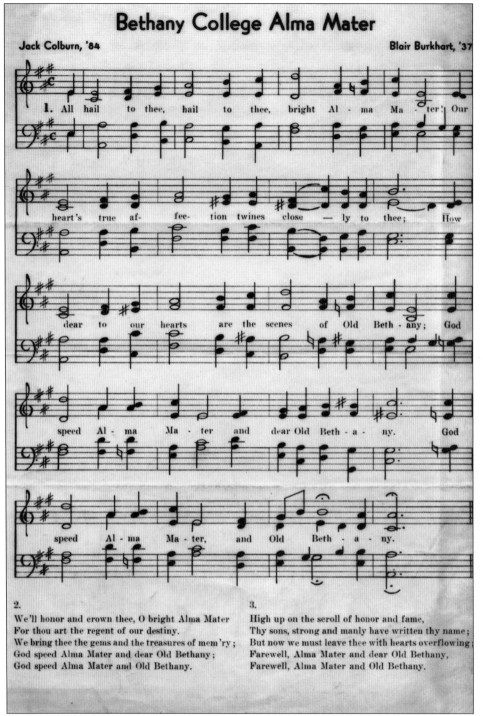

Bethany College Alma Mater

Jack Colburn, '84 Blair Burkhart, '37

1. All hail to thee, hail to thee, bright Al - ma Ma - ter! Our

heart's true af - fee - tion twines close — ly to thee; How

dear to our hearts are the scenes of Old Beth - any; God

speed Al - ma Ma - ter and dear Old Beth - a - ny. God

speed Al - ma Ma - ter, and Old Beth - a - ny.

2.
We'll honor and crown thee, O bright Alma Mater
For thou art the regent of our destiny.
We bring thee the gems and the treasures of mem'ry;
God speed Alma Mater and dear Old Bethany;
God speed Alma Mater and Old Bethany.

3.
High up on the scroll of honor and fame,
Thy sons, strong and manly have written thy name;
But now we must leave thee with hearts overflowing;
Farewell, Alma Mater and dear Old Bethany,
Farewell, Alma Mater and Old Bethany.

"ALMA MATER," 1937. The Bethany College alma mater was written by A. Jack Colburn Jr. (Class of 1894) and put to Blair Burkhart's (Class of 1937) music in 1937. The original words were set to the tune of "The Old Oaken Bucket." Mr. Colburn dedicated the new song to Blair Burkhart.

The Campus History Series

BETHANY COLLEGE

BRENT CARNEY

ARCADIA
PUBLISHING

Published by Arcadia Publishing
Charleston, South Carolina

Printed in the United States of America

Library of Congress Catalog Card Number: 2004103404

For all general information contact Arcadia Publishing at:
Telephone 843-853-2070
Fax 843-853-0044
E-mail sales@arcadiapublishing.com
For customer service and orders:
Toll-Free 1-888-313-2665
Visit us on the Internet at www.arcadiapublishing.com

This book is dedicated to my parents,
William A. Carney Jr. and Sheila Carney.

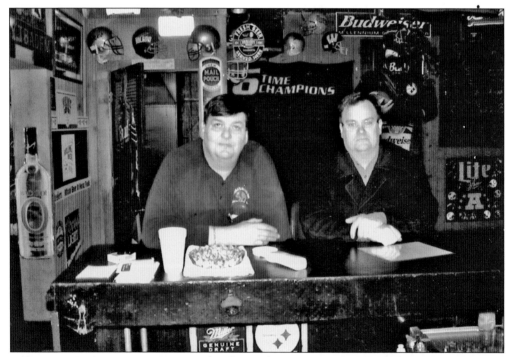

BRENT AND BUBBA, MARCH 20, 2004. The author, Brent Carney (right), is sitting with Bill "Bubba" Reid in Bubba's Bison Inn. Brent teaches history at Wheeling Jesuit University and is a consultant for the Wheeling National Heritage Area Corporation. The last time he was in this bar was 15 years ago when Bubba made his friends Ems, Pro, Cream, and Brent himself leave town after fighting. All has been forgiven.

CONTENTS

ACKNOWLEDGMENTS

I would like to thank the following people for their help in the construction of this book: President Patricia Lewis Poteat, Dave S. McMullen, Wilbur "Wib" H. Cramblet, Hank Cook, Ted Williams, Felicity Ruggiero, George Miller, Hollis Craft, Ann Craft, Chuck Kern, Fujiko Sawtarie, Kirk Reed, Jeff Evans, Lynn Davis, Hal O'Leary, Carl A. Kaylor, Chris Snyder, Don Burns, Gary Larson, Joyce Chernenko, John S. Cunningham, Bob Chambers, Charlotte Chambers, George Sleime, Frank Calabrese, Kosmas Mouratidis, Laura Slacum, John Taylor, Albert "Jay" Buckelew, Cathy Gordon, John McGowan, Todd Jones, Janice L. Forsty, and Bill "Bubba" Reid.

I'm grateful to my employer, Hydie Friend, for giving me time off work to complete this book. I must also thank the students of Bethany College who took time out from their studies and allowed me to take their photograph. A special thanks to Rudy Agras, Ed Parshall, and my friends from Newbrough Photo for technical assistance.

Finally, I have to acknowledge the extraordinary help and access given to me by R. Jeanne Cobb, archivist and coordinator of special collections of the T.W. Phillips Memorial Library. Mrs. Cobb is the Rosetta Stone of Bethany College information in that she is the only person who can translate the diverse Bethany facts, figures, legends, lore, places, and people into one understandable theme. Visiting her in her archives when she has on her white gloves is akin to meeting an archeologist carefully handling an irreplaceable Grecian urn. Her meticulous care of Bethany's archives should make every Bethanian feel confident that their legacy is being preserved by a loving professional. She spent dozens of hours with me scouring through the folders and files in the library to make certain that everything was correct.

INTRODUCTION

Located in a picturesque village in West Virginia's northern panhandle is Bethany College. It was founded on March 2, 1840, by Alexander Campbell. He was a maverick philosopher and one of the most important religious reformers and educators of the 19th century. Campbell acted as a prime catalyst in the establishment of what would become the Christian Church (Disciples of Christ). This Renaissance man was an inventive sheep farmer, educator, theologian, postmaster, businessman, author, debater, printer, suffragist, and devoted father. Sen. Henry Clay introduced him to a group of distinguished foreign dignitaries as one of "the most eminent citizens of the United States." President James Madison called him "the ablest and most original expounder of the Scriptures I have ever heard." Mr. Campbell provided land and funds for the college and served as its first president.

Bethany fits nicely into most high school seniors' daydreams of a quaint college town with Greek fraternity houses and ivy-covered buildings. It is the oldest degree-granting institution in the state of West Virginia. While the laboratories and teaching methodology are now cutting-edge, the college has retained its oldest and most cherished traditions. The town and campus contain several nationally known architectural masterpieces. Bethany has six locations listed on the National Register of Historic Places: Old Main, Old Bethany Church, Pendleton Heights, the Delta Tau Delta Founder's House, the Alexander Campbell Mansion, and the Bethany Historic District. In addition, many buildings are listed as National Historic Landmarks. Bethany's richest legacy is her faculty and alumni, which include Amos Emerson Dolbear, whose patent for the telephone was just days behind that of Alexander Graham Bell. The NBC News broadcaster Faith Daniels went to Bethany, as did Oscar-winning actress Frances McDormand. The United States assistant attorney general John Marshall studied here, as did associate justice of the Supreme Court Joseph Rucker Lamar. Bethany has also seen its share of philanthropists, including Earl Oglebay, Thomas Wharton Phillips, and Mark Mordecai Cochran. The alumni mirror the college and the town in their strident independence and singular character.

Bethany College serves as a testimony to how a small college's alumni and architecture can have an enormous impact on American history. It does not attempt to be a complete description of Bethany College but rather hopes to provide the reader with just a glimpse of the rich history of this area. In fact, the most difficult part of the process was not where to find photos but what to leave out. This book has made extensive use of the archives and special collections of the T.W. Phillips Memorial Library. Many of the photographs and manuscripts have not been seen by the general public. I have included photographs and information from every decade of the college's existence. Unless otherwise noted, all the photographs and documents in this book came from the college archives.

One

ALEXANDER CAMPBELL

YOUNG ALEXANDER CAMPBELL, 1818–1829. This is the earliest known likeness of Alexander Campbell, showing him between the ages of 30 and 41. Alexander was born the son of Thomas and Jane (Corneigle) Campbell in the parish of Broughshane, county of Antrim, Ireland. Thomas Campbell was a Presbyterian minister who emigrated to America in 1807. Alexander attended the University of Glasgow, where it became evident that he was an independent thinker, would not follow the narrow confines of any denomination, and was destined to forge his own theological path.

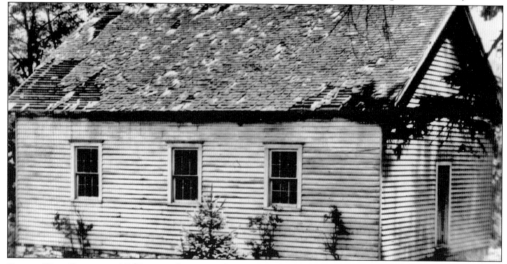

NOTICE TO PASSENGERS.

THOSE who intend going to America in the Ship

HIBERNIA,

BOUND TO

NEWCASTLE & PHILADELPHIA,

Are requested to be on Board by the 20th inst. as the Vessel will proceed on her Voyage with all possible expedition after that date.

JOHN KELSO.

SAMUEL GLEN.

HIBERNIA **ADVERTISEMENT, 1808.** Alexander Campbell's voyage to America began with an adventure when his ship, the *Hibernia*, shipwrecked on October 7, 1808. The *Belfast News* reported a "dreadful storm" that dashed the ship onto jagged rocks off the Isle of Islay near Scotland. All survived the harrowing journey, but it must have left Alexander Campbell with the feeling that providence had spared him for some reason. In 1809, he joined his father in western Pennsylvania and initially allied himself with the Presbyterian Church. Later, he moved closer to the teachings of the Baptist Church, but in time they parted ways. He called for religious reformation based upon liberty, equality, and freedom from denominational constraints. Alexander Campbell, along with Barton Warren Stone, Thomas Campbell, and Walter Scott, became a founding father for the Christian Church (Disciples of Christ).

BRUSH RUN CHURCH, 1949. Brush Run Church was the first church of the Christian Church (Disciples of Christ). It was originally erected near the junction of Brush Run and Buffalo Creek, Washington County, Pennsylvania. The original deed for the land was issued on September 27, 1810, and was finished soon after June 16, 1811. When Alexander Campbell started as a preacher, he refused all payment. He preached of the imminence of the Second Coming, and he actually set the date for 1866—the same year that he died. In June 1916, the Brush Run Church was rebuilt in the side yard of Campbell Mansion after having been used as a barn and stable in West Middletown for many years. It was finally dismantled in the fall of 1949.

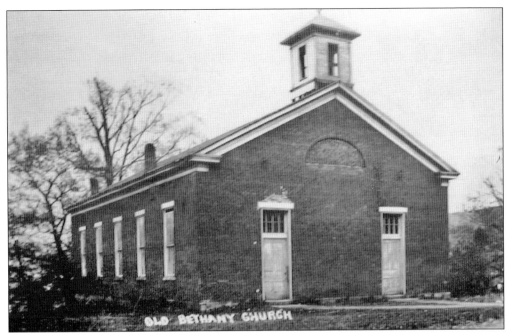

OLD BETHANY MEETING HOUSE, 1852. Alexander Campbell preached in this church, and it is now seen as the symbolic mother of the Christian Church (Disciples of Christ). It was repaired at least three times before 1915 and held regular worship services from 1852 to 1915. It has a seating capacity of about 300, and it was customary for single women to sit on the left side of the aisle and for single men to sit on the right side. Families were expected to sit together. The church was added to the National Register of Historic Places in 1976.

CAMPBELL MANSION, 1858. Alexander Campbell's father-in-law, John Brown, built this home from 1792 to 1795. Campbell and Margaret Brown were married in John Brown's parlor. John Brown deeded the house and 350 acres to his son-in-law on March 27, 1815, for $1. The house was built in four stages, between 1792 and 1840, and was famous for its warmth and hospitality. It played host to Jefferson Davis, future president of the Confederacy; James Garfield, future president of the United States; and many others. Pictured on the right side of the photograph is possibly Jim Poole, one of Alexander Campbell's slaves. While Campbell's views on slavery were complicated, he arranged for his slaves to be granted their freedom once they reached a certain age. The Campbell Mansion was also the site of Alexander's first school, the Buffaloe Seminary (1818–1822).

SPRING HOUSE, 1880s–1890s. The Spring House probably served as a dairy. Alexander Campbell was an entrepreneur who had successfully bred and raised New England Saxony and Merino sheep prior to 1832. He imported a flock of European sheep and cross bred them to produce a heartier breed. At one point, he had over 1,500 head of sheep. He also raised Percheron horses; grew hops, corn, pumpkins, sweet potatoes, apples, and wheat; and produced or gathered his own medicinal and culinary herbs. One year, Campbell sold 400 pounds of butter.

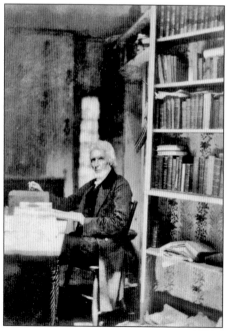

BISHOP IN HIS STUDY, 1858. Alexander Campbell was one of the ablest debaters of his era. He carried on a series of famous intellectual duels that garnered him a reputation as a maverick philosopher. He debated infant baptism with John Walker (1820), baptism with W.L. McCalla (1823), the truth of Christian revelation with Robert Owens (1829), the Roman Catholic Church with Bishop Purcell of Cincinnati (1837), and Presbyterianism with Nathan L. Rice (1845). During his famous eight-day debate with Bishop Purcell, Campbell quoted 17th-century scholar Alphonsus Liguori about "clerical concubinage," only to be denounced by Bishop Purcell as bearing false witness against his neighbor. After the debate, Campbell produced the manuscript and was proven correct. His skills as an orator were so noted that he was selected as a delegate to the 1829 Constitutional Convention in Richmond, Virginia, where he argued for "one man–one vote."

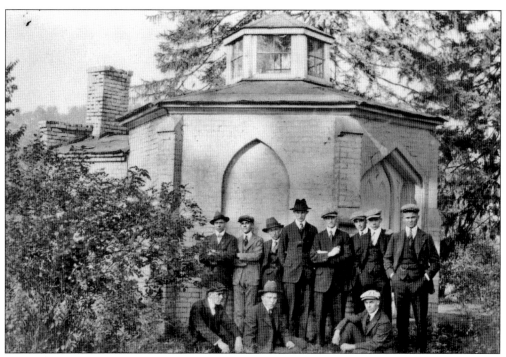

CAMPBELL STUDY, 1916. This hexagonal structure was built from 1832 to 1836. Alexander Campbell became the first postmaster of Bethany (1827–1865) so that he could send his voluminous correspondence (over 100 per week) without paying for stamps, as the postmaster had franking privileges. Campbell established Bethany as a postal district on June 2, 1827. He kept in constant touch with the great thinkers and political leaders of the 19th century. In 1858, he traveled to the White House to talk with President James Buchanan. Thomas Bradt took this photograph of several young men paying homage to the Bishop's study.

ALEXANDER AND SELINA, 1861. Campbell's first wife, Margaret Brown Campbell, died in 1827, and one year later he married his second wife, Selina Huntington Bakewell. This photograph of Alexander Campbell and his wife Selina was taken at a convention in Cincinnati in 1861. She was the perfect hostess and once said, "Our visitors for years were numerous, and often their visits were protracted, but all were always made to enjoy a home feeling, at least that was the desire of the host and hostess; indeed, it was the intensity of feeling and the importance of scripturally entertaining strangers that lessened all the care and necessary labor."

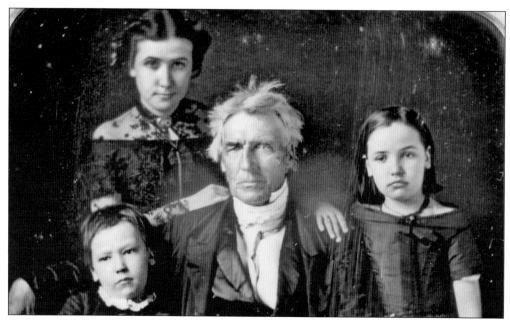

CAMPBELL AND KIDS, 1847. Campbell's children, from left to right are Virginia (standing back), William, and Decima. Alexander had eight children with Margaret: Jane Campbell Ewing (1812–1834), Eliza Ann Campbell Campbell (1813–1839), Maria Louisa Campbell Henley (1815–1841), Lavinia McGregor Campbell Pendleton (1818–1846), Amanda Corneigle Campbell (1820–1820), Clarinda Campbell Pendleton (1821–1851), John Brown Campbell (1822–1822), and Margaretta L. Campbell (1824–1826). He had six children with Selina: Margaret Brown Campbell Ewing (1829–1848), Alexander Campbell Jr. (1831–1906), Virginia Ann Campbell Thompson (1834–1908), Wickliffe Ewing Campbell (1837–1847), Decima Hemans Campbell Barclay (1840–1920), and William Pendleton Campbell (1843–1917).

THE

Millennial Harbinger.

DEVOTED TO

Primitive Christianity.

CONDUCTED BY

ALEXANDER CAMPBELL.

CO-EDITORS:
W. K. PENDLETON AND A. W. CAMPBELL.

VOL. IV.] JULY. [No. VII.

BETHANY, VA.:
PRINTED AND PUBLISHED BY A. CAMPBELL.
1854

Day of Publication—the First Monday in every Month.

Postage on the Harbinger, 6 Cents per Annum, Quarterly in Advance.

THE MILLENNIAL HARBINGER, JULY **1854.**
Alexander Campbell was an influential publisher who produced a common language translation of the *New Testament* (1826), the *Christian Hymnal* (1828), the *Christian System, The Memoirs of Elder Thomas Campbell,* the *Acts of the Apostles,* the *Popular Lectures,* and *Addresses, Christian Preacher's Companion and Christian Baptism: Its Antecedents and Consequences.* He printed seven volumes of the *Christian Baptist* (1823–1830) and 34 volumes of *The Millennial Harbinger* (1830–1863). He also published some of his famous debates and his influential *Sermon on the Law,* which is still discussed today.

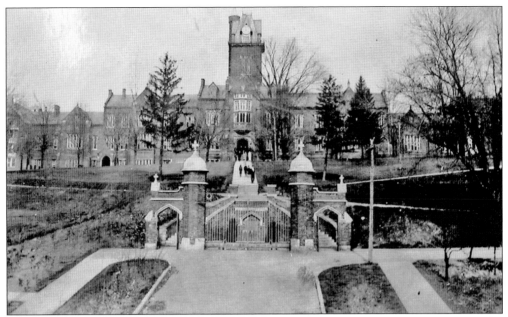

BETHANY COLLEGE, 1913. Alexander Campbell founded Bethany College on March 2, 1840, and served as its first president until his death in 1866. He donated the money and land to start what was one of only 100 colleges in the United States and the sole one in western Virginia. It is the oldest degree-granting institution in West Virginia. Alexander Campbell took an active hand in the design of Old Main, which is now a National Historic Landmark and is on the National Register of Historic Places.

FACULTY, 1856. Clockwise from the top are Alexander Campbell, president and professor of sacred literature; William Kimbrough Pendleton, professor of natural, political, and intellectual philosophy; Robert Milligan, professor of mathematics and astronomy; Peter William Mosblech, teacher of Hebrew and modern languages; Robert Richardson, professor of natural history, physiology, rhetoric, and chemistry; and Andrew Finley Ross, professor of ancient languages and literature. The residences, clockwise from the top right, are Professor Pendleton's residence (Pendleton Heights), Professor Ross's residence (the Nancy Huff home), Bethany Church (Old Bethany Meeting House), Professor Milligan's residence (Hibernia), Professor Richardson's residence (Bethphage), Elder A. Campbell's residence (Campbell Mansion), and the College Building (College Proper), center.

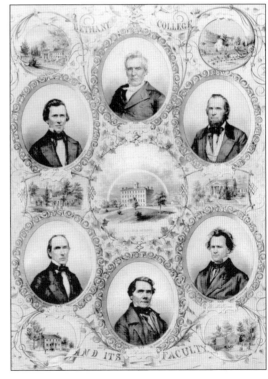

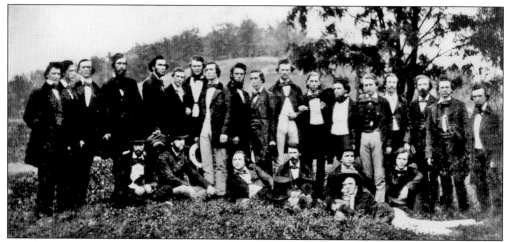

CLASS OF **1858.** This is the earliest extant photo of a Bethany College graduating class. Alexander Campbell believed that students should receive moral as well as intellectual instruction in order that a graduate of Bethany College would become a well-rounded person. Alexander Campbell was an innovator in childhood education and an outspoken champion of universal female education.

"GOD'S ACRE," LATE **1930s.** Campbell believed that this hillside was the most beautiful that he had ever seen, and so he had it consecrated in 1820. He wasn't the only person to be so impressed, as the poet Carl Sandburg once said of this spot, "Here time placed a hand." The inscription on Alexander Campbell's monument reads: "In Memoriam, ALEXANDER CAMPBELL Defender of the Faith, Once delivered to the Saints, Founder of Bethany College, Who being Dead yet speaketh by his numerous writings and holy example. Born in the county of Antrim, Ireland, September 12, 1788, Died at Bethany, Va., March 4th, 1866." His daughter Amanda was the first person to be buried in the cemetery (1820).

Two

BETHANY

BETHANY JAIL, SEPTEMBER 1917. The reverse side of this postcard reads, "Photo of old Bethany Lock up sold to highest bidder for $5.80. The present incumbent is corn fodder. Picture and article run in all big city newspapers and magazines. A.D. Benjamin and Gus Miller in picture." The photographer appears to be John J. Scott. This jail seems to be a temporary "drunk tank" so that the sheriff would not have to make the long journey to Wellsburg every time someone got a bit rowdy.

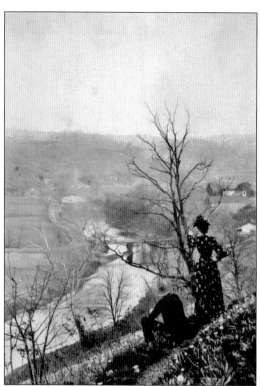

COUPLE VIEWING BUFFALO CREEK, 1890–1897. Note the belfry on the Old Bethany Meeting House on the right hand side of the photo. At least three times before 1915 the church was repaired, modified, or renovated. At some time prior to 1897, a small wooden belfry was added to the roof at the west end; it was removed in 1920. This photo was taken from Reservoir Hill. Prior to 1827, the Bethany area was a part of Buffalo Township, Virginia. In that year Alexander Campbell created the Bethany Postal District in Buffalo Township so that he could keep up with his many correspondences and publications. The town was incorporated in 1853.

BETHANY FROM THE HAYSTACKS, 1880s. This is a view of Roosevelt Street from the east, and the haystacks are in "Decima's Round Bottom." Today the Bethany Town Park is located in this plot of land once owned by Decima Hemans Campbell Barclay. The little boy standing next to the front haystack is wearing pants and what looks to be a winter jacket. The tower can barely be seen in the background. Note how few houses have been built on this side of town.

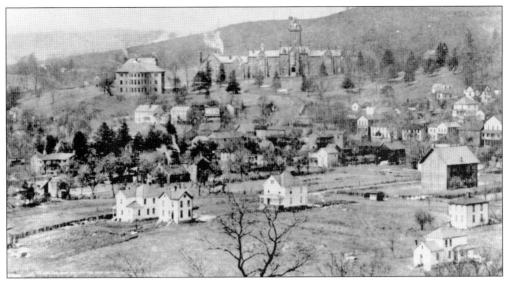

BETHANY OVERVIEW, 1909. On the far right with its back to the viewer is the Methodist Episcopal Church. The Carnegie Library was built between 1906 and 1908 and can be seen to the left of Old Main. Notice the smoke coming from Old Main, which is probably why there are so few trees on the hillside. Cochran Hall (1912) and the Bethany Memorial Church (1914) would be in the photo but have not yet been built. The photographer was standing on the Greek Letter Hill. Notice the lack of vegetation on Reservoir Hill at the far right behind Pendleton Heights.

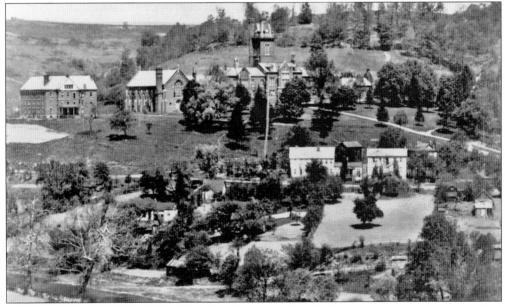

BETHANY FROM THE SOUTH, 1908. This snapshot was taken looking north around the time that the first trolley came through Bethany on October 29, 1906. The two white buildings in front of Carnegie Library were the Kentucky House and the Virginia House. These boarding houses were operated by Isaac and Sophie Stewart, whose Ranche occupied the corner where Cochran Hall now sits. The empty field in the foreground is where Campbell Hall is presently located. Phillips Hall is the large structure on the far left

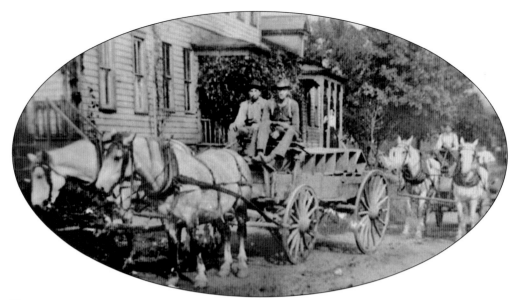

FARMERS TO MARKET, LATE 1800s. The renowned inventor of the telephone, Amos Emerson Dolbear, was asked to be the first mayor of Bethany in 1871. He set down regulations, including one "making it unlawful to hitch horses across sidewalks." The farmers of the surrounding country took great offense to that regulation, and some declared that they would hitch their horses where they pleased when they came to town. Later Dolbear found "an obstreperous boy who refused to move his horse when ordered to do so." The boy was fined $1.

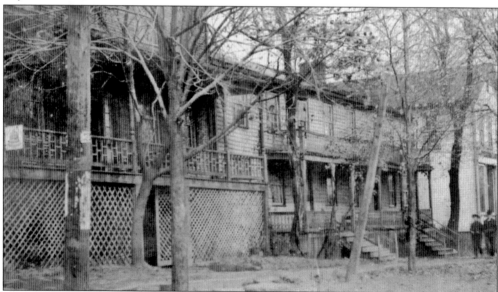

MAIN STREET, 1890s. One can see on the far left the Old Bethany House, which was owned by the Fowler family. It was a boarding house and an inn for students. The Bethany College Bookstore sits there now. The original Bethany House sat to the right on what was the house of John T. Lauck, where he ran a boarding house. When Mr. Lauck moved to Wellsburg in 1882, the Fowlers asked for his Bethany House sign and thus took the name. The white building on the far right was the original Chambers Store.

SQUIRE BILLINGS'S BLACKSMITH SHOP, 1880s. This vital facility was located at the corner of Ross and Richardson Streets. Billings was said to be a welcoming, tobacco-chewing character. His shop was the local hangout for gossipers, who sat outside on upturned kegs and talked about their neighbors. This was behind the location of present-day Bubba's Bison Inn.

SELF-SERVICE MARKET, 1970s. The John Huff Building has housed diverse ventures, including a grocery store, a bookstore, and a post office. In 1977 it became Bubba's Bison Inn. Frank Calabrese was the first person to get a liquor license in Bethany for his bar Page Two, which was on Main Street. This bar later changed its name to the Wooden Keg. Bubba's was once the site of The Enterprise, which had "ice cream–style" chairs. Today, one can see a certificate on the wall declaring that Coach Brian Murphy once won a bet in which he had to do 1,000 push-ups in four hours. The large tree in the photo is no longer there.

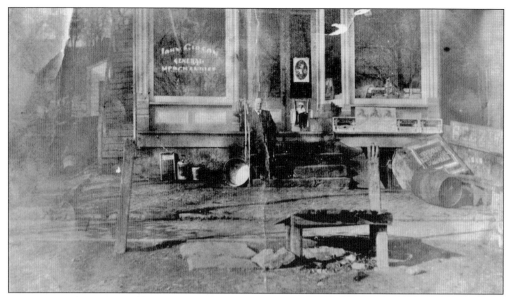

GIBSON'S STORE, 1889. John Gibson operated Gibson's Cash Store at least as early as 1885. He opened a new store in the fall of 1889 on the site that is now The College Inn. Notice the mounting block; this was used by the ladies so that they could elegantly dismount their horse without splashing in the mud. Two hitching posts can also be seen. The street appears to be little more than a dirt path. Bethany, once described as "Mudville," at one time required stepping stones to cross the street.

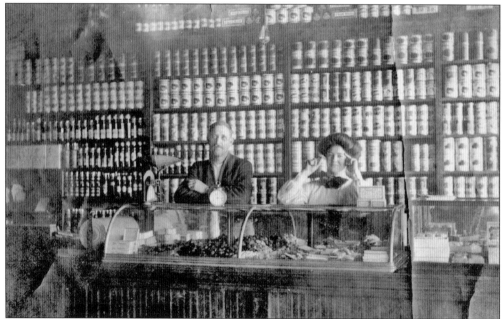

JONES STORE, 1915. This store sold penny candies, canned vegetables, cigars, and household goods. The box on the counter reads "Delicious Zig Zag." The woman has a well-coiffed pompadour hairstyle and is holding a piece of penny candy. This location is now the site of Chambers General Store and was the second location for Chambers Store. It is still a place to buy groceries and make small talk with other students and locals.

OLD METHODIST EPISCOPAL CHURCH, 1880s. This church was built in 1872 as an attempt to cater to those Bethanians who did not belong to the Disciples of Christ. Before 1900 two congregations sometimes met for Thanksgiving, alternating the location. However, there was not enough demand to sustain a congregation and the church folded by 1927. In 1929 it became the Sigma Nu Chapter House after the original burned in 1927.

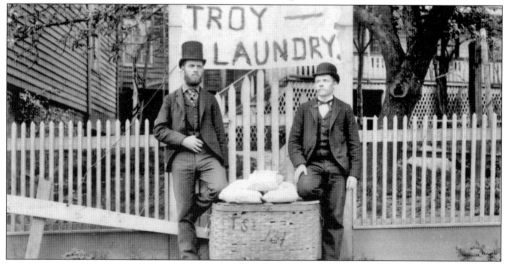

TROY LAUNDRY AGENTS, 1880s. In the early days students could wash only so many clothes per week at the college laundry. The faculty decreed, "The clothes to be washed for each student shall not exceed nine pieces in winter, and twelve in summer, per week; and whenever the washing shall not be done in proper manner, the Faculty may authorize the Students to have it done elsewhere, and deduct the price thereof from his board." These men picked up the slack for the messier students. The laundry was in the basement of Bethany House.

23

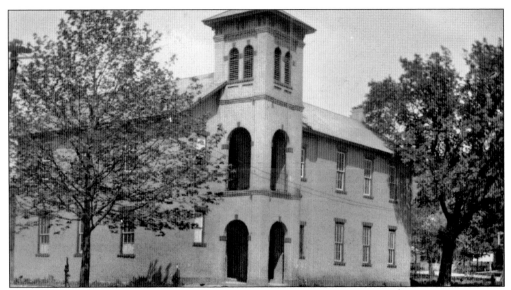

OLD BETHANY SCHOOL, 1890. This elementary school, built in 1868, was located on the corner of Church and Richardson Streets. There appears to be an old water pump next to the tree. The school had three rooms into which students were divided according to their arithmetic abilities. Miss Maggy Campbell, Miss Bertie, and Miss Rebecca Anderson were some of the well-known arithmetic teachers. In 1948 it became the site of the Beta Theta Pi fraternity house, which is now vacant because their chapter closed on February 5, 2003.

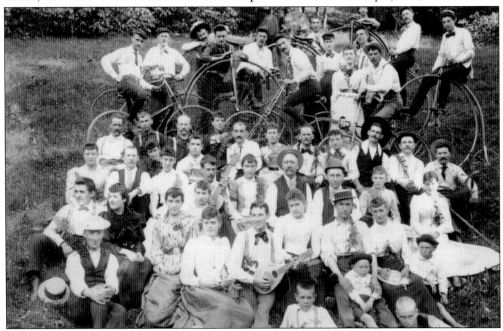

FAMILY OUTING, JUNE 26, 1892. This photograph is signed by H.C. Apparently, H.C. and some townspeople had a picnic somewhere in Bethany and decided to bring their bicycles. Strangely, many of the people hold ferns and one gentleman plays a mandolin. One man in the back of the group is on horseback, while others are sporting boating hats and bow ties. This is not a combination that you are likely to see today at Oglebay Park.

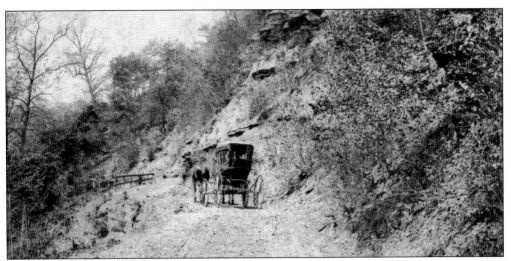

STAGECOACH ON "THE NARROWS," 1860s–1870s. This albumen print features a stagecoach traveling the seven miles to Wellsburg on today's Route 67. This road was the main artery to and from Bethany and was constantly being used by students whenever they had to go home during summer vacations. Two sections of the road got the nickname "The Narrows" due to the lack of girth and the steep drop-off. Many students came to school by boat via the Ohio River or by the railroad and were dropped off at Wellsburg. The road presented the added danger of cave-ins due to the plethora of coal seams and loose limestone.

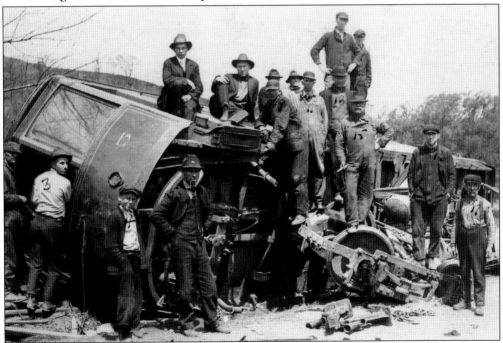

WRECK OF THE BETHANY CAR, MAY 8, 1917. The accident occurred at the foot of Buchanon's Hill, which is on Route 67, past the "First Narrows." On May 8, 1917, car No. 5 of the Wellsburg Bethany and Washington Street Railway Company crashed when its brake rod snapped but not before it ran wild for a quarter of a mile. Several of the 30 passengers aboard were seriously injured, and one person, a Mr. Clymer, was killed.

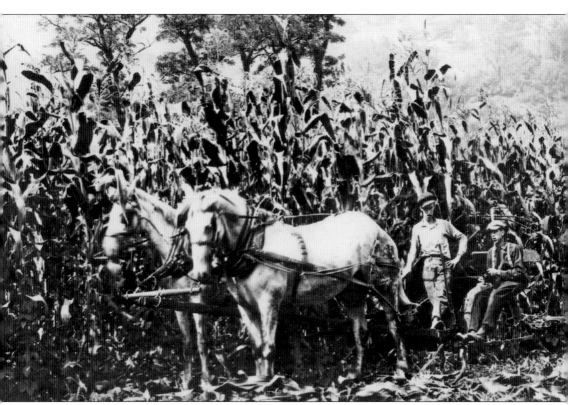

COLLEGE FARM, 1913. Bethany maintained a farm to teach the latest agricultural techniques to Bethany students. Notice that the corn stalks were 10 to 12 feet tall. The small cutting device that the boys were using was probably state-of-the-art for the day.

Three

ARCHITECTURE

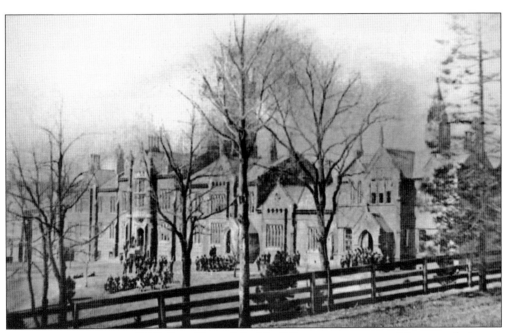

OLD MAIN, PRIOR TO THE 1879 FIRE. The original building was constructed in stages between 1858 and 1871. The architect was James Key Wilson of Walter and Wilson, Cincinnati. The Gothic Revival building resembles the University of Glasgow in Scotland. The Oglebay Hall of Agriculture was added in 1911–1912 to replace Society Hall, which burned down in 1879. This is a rare photo showing Society Hall before its destruction. Oglebay Hall was constructed in the Tudor Gothic style. Alexander Campbell believed that Gothic architecture best expressed the style and spirit of the new nation. He said, "The Gothic has been adopted as the style most fitly expressive of the inspiring nature of the Christian's aims and hopes." Old Main was added to the National Register of Historic Places in 1970 and became a National Historic Landmark in 1982.

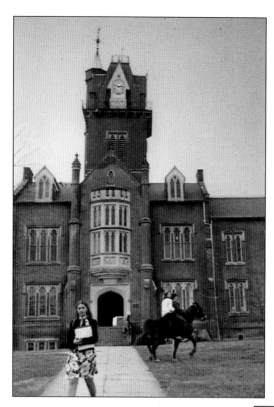

THE TOWER, 1970s. The 22-foot-square and 96-foot-high Campbell Tower is surmounted by a spire 122 feet from the ground. In the spring of 1891, George Bonar and six freshmen led a cow up the 160 wooden steps of the tower as a gag. They tied a sign to it that said "Beef is UP!" The cow was left there overnight but wasn't slaughtered, despite what the legend says. It seems that many people have been credited with taking a cow up the stairs, including Don Knotts and Tom Poston, but this is the only confirmed story. Alexander Campbell's ghost is said to inhabit the parapet.

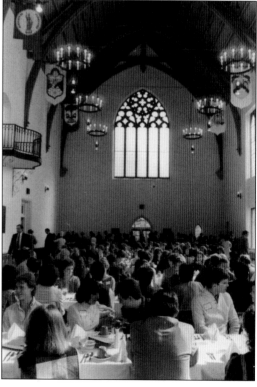

COMMENCEMENT HALL, LATE 1980s. The original stone foundation was laid in 1860, and the construction lasted from 1869 to 1871; it was used as a gym from 1890 to 1903. This became the Norman A. Phillips Dormitory for Men in the fall of 1903. Later, the upper level was used as an auditorium and the lower half as a physics classroom. The windows were remolded in Gothic style. Between 1982 and 1984 the hall was restored to its original form. Banners with state and university crests hang from the Gothic arches, which are 55 feet above the slate floor. The hall is still used for concerts, convocations, and dinners, as well as theatrical and musical productions. It has also been the site of speeches of five former U.S. presidents.

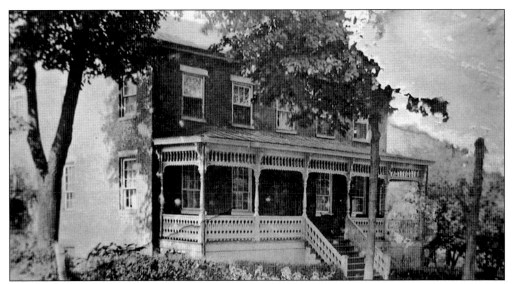

HIBERNIA, 1890–1951. The basement of the Hibernia was built around 1841 and the upper floors were added between 1845 and 1847. It was used as a printing office for *The Millennial Harbinger*. While the basement was used for printing, the first floor acted as a boarding house. It is listed as a part of the Bethany Historic District. In 1982 a total of 40 buildings in the town and college were entered together on the National Historic Register as the Bethany Historic District. From the 1840s to 1951 the Hibernia was used as a boarding house, a guesthouse, and a private residence. Currently the college president lives in this historic building. It is possible that the name comes from the ship that brought Alexander Campbell to America.

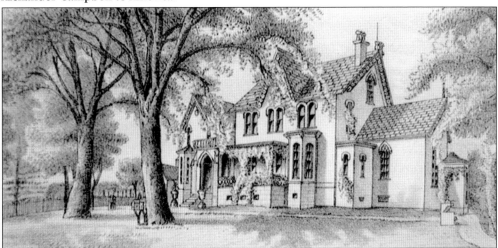

PENDLETON HEIGHTS, 1879. This is the oldest building at Bethany College and was built as the home of William Kimbrough Pendleton between the fall of 1841 and June 20, 1842. The original name of the location was the Hill of Flowers before it became Mount Lavinium in 1846–1848 to honor Pendleton's first wife, Lavinia McGregor (Campbell) Pendleton. It was used as a faculty home and later as the president's home. From 1889 to 1892 it was a women's dormitory called Ladies Hall. Its core was built in the Federal style and was remolded in 1870–1871 in the Gothic style to resemble Old Main. It was listed on the National Register of Historic Places in 1975.

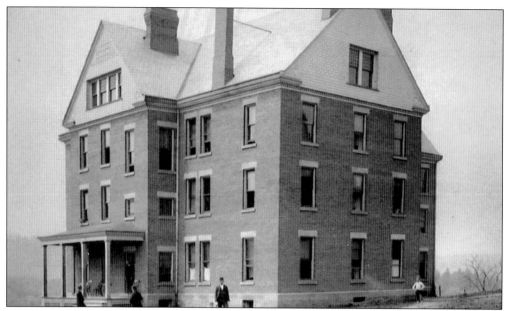

PHILLIPS HALL, 1891–1892. Construction was completed on Phillips Hall in June 1891. It was built by S.W. Foulk and served as a men's dormitory possibly from February 1, 1891, to June 1891, and more certainly from September 1891 to the close of the spring session in 1892. It became a women's dorm in the fall of 1892 and has continued as such until recently. One exception was when it was used as a dorm for the navy V-12 program from 1943 to 1945. Two ghosts have been seen in the dormitory, including a sailor climbing a drainpipe to court a girl. Legend says he fell to his death and still haunts the hall. The second is a young girl who appears, takes things, and turns radios and lights on and off. This kleptomaniac poltergeist is said to have committed suicide.

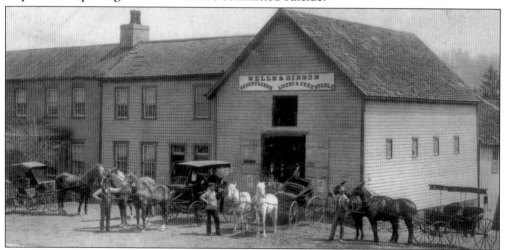

BETHANY COLLEGE INFIRMARY, 1902–1906. This building was once attached to William Pendleton Cowan's Livery Stables and was built by Jacob E. Curtis. Between 1866 and 1867 it served as a house. The Livery and Stables were built between 1880 and 1882 and were gone by 1914. In 1906–1907, a sign on the shop read "Wells & Gibson. Undertakers, Livery & Feed Stable." It was one of the earliest town buildings, and Bethany College's first physician, Samuel Sprigg Jacob, lived there. These buildings sat on lots 66–67 on Main Street.

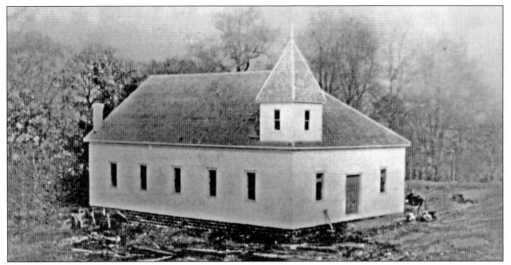

OLD GYM, 1903–1915. The old gym was burned by an arsonist using kerosene on April 27, 1915. The Irvin Gymnasium was built between 1917 and 1919 on the same spot. The new 45-by-47-foot wooden structure was the site of riots in the spring of 1919. In that year the student body protested forced enrollment in the Student Army Training Corps and made Irvin Gym their headquarters. The structure was remodeled between 1983 and 1984 and became the Grace Phillips Johnson Memorial Visual Arts Center. Security guards swear that the ghost of Grace Phillips Johnson resides in the building. The eyes of her portrait appear to follow viewers.

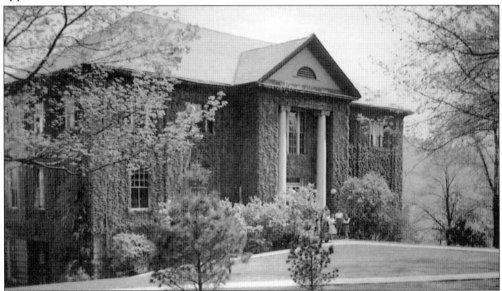

CRAMBLET HALL, 1940s. The Carnegie Library was built between 1906 and 1908 after the millionaire Andrew Carnegie promised to donate $20,000 for this library if the college could find matching funds. Green lumber was used and warping soon began. The roof sagged because of termites and the weight of the books caused the center of the building to sag. The tension pulled the staircase away from the wall. After the T.W. Phillips Library was built in 1960, the Carnegie Library was shored-up, remodeled, converted into administrative offices, and rededicated as Cramblet Hall on June 3, 1961.

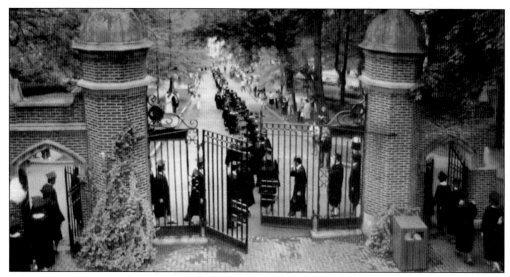

OGLEBAY ENTRANCE GATES, LATE 1980s. The gates were put into place in 1910; Earl Williams Oglebay provided the funding and the gates are named for him. One of Bethany College's most cherished rituals is when students pass through Oglebay Gates into the college during matriculation and once more at commencement. The act is connected to the college seal that was designed by Professor Richardson in 1843. The motto on the seal is "Pharetram veritas, sed arcum Scientia donat" (science furnishes the bow by which the arrows of truth are directed). The bows and arrows arm students with a quality liberal arts education; by passing through the gates at commencement they demonstrate being so armed.

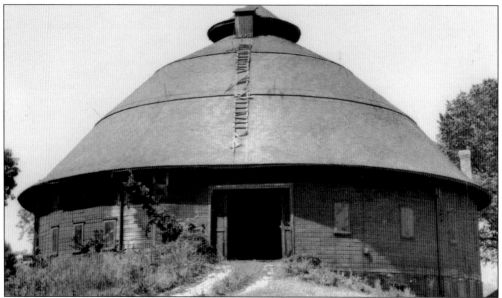

ROUND DAIRY BARN, 1940s. Architect George A. Clymer designed the Round Barn in 1912. The eggshell design was used for the self-supporting conical roof. The interior diameter of the silo was 14 feet, and the cows on the basement floor were arranged in two circles. The farm was established between 1911 and 1912 as an Agricultural and Horticultural Experiment Station. The Round Barn, set across the road from Campbell Mansion, was used by the college for dairy cattle until 1955 and was destroyed in the late fall or early winter of 1973.

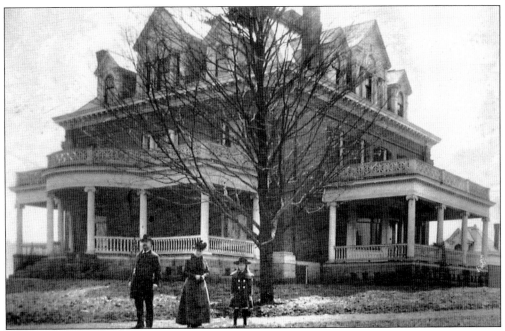

POINT BREEZE MANSION, 1904. This Colonial-style mansion was built for William H. Nave (Class of 1863) in 1900 by the architectural firm Giesey and Faris from Wheeling, West Virginia. The photo shows William H. Nave, Jessica Campbell Nave, and their daughter Jessica. The mansion was originally the site of the Primary and Preparatory Institution built by Alexander Campbell between 1842 and 1843. Purchased by Bethany College in 1937, it later became a tearoom and hostelry for single faculty members. In the fall semester of 1942 Point Breeze was used as a barracks for the navy V-12 Program. In 1953, the Beta Gamma Chapter of Alpha Sigma Phi fraternity purchased Point Breeze. The fraternity occupied the house until spring 2000–2001. It is currently boarded up.

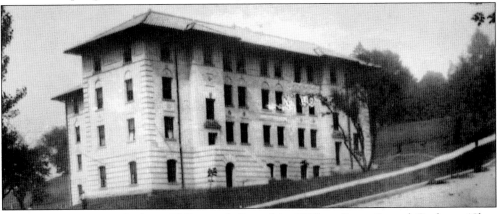

COCHRAN HALL, 1912. Cochran Hall was dedicated in 1912 to Percy Bayard Cochran (Class of 1900), son of Marc Mordecai Cochran. The building rests on the site of Isaac and Sophie Stewart's Ranche and the famous Stewart Spring. The Ranche was torn down around 1909. In the winter of 1910 an epidemic of typhoid fever broke out, and it was believed that the spring was contaminated from the torn-down Ranche buildings. Cochran Hall was originally used as a men's dormitory but was used as faculty offices in succeeding years and now sits vacant. There is reported to be a harmless ghost in the guest apartment on the first floor.

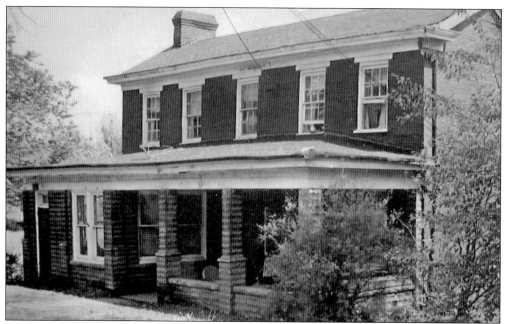

DELTA TAU DELTA FOUNDER'S HOUSE, 1950s. The Greek Revival structure was built between 1853 and 1856 and was originally called the Delta Tau Delta Chapter House. The national chapter was founded in May 12, 1859, by eight Bethany students: Jacob S. Lowe, Richard H. Alfred, Henry K. Bell, William R. Cunningham, Alexander C. Earle, John L.N. Hunt, John C. Johnson, and Eugene Tarr. The chapter was discontinued during the Civil War and returned to Bethany in 1867. The charter was withdrawn in 1895 and became active again in 1965–1966. The building was placed on the National Register of Historic Places in 1979. It is being prepared for use as the national archive for the fraternity.

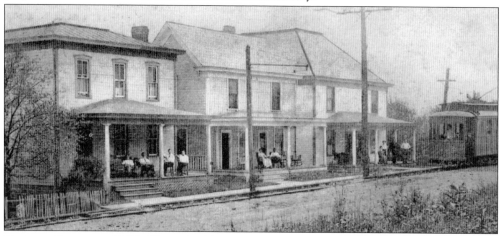

COCHRAN COTTAGES, 1918. These buildings were used as female auxiliary dormitories for Kappa Delta, Phi Mu, and Alpha Delta Theta sororities because Phillips Hall was filled. They were located on Main Street where the Bethany Memorial Church and Campbell Hall now sit. In the fall of 1936 they were remodeled and redecorated with new floors, a kitchenette, reading rooms, and large recreational rooms. Cochran Cottages were moved behind the Bethany Memorial Church in the fall of 1954 so that a new men's dormitory could be built. M.M. Cochran donated money for the original cottages to be constructed.

Four

LEGENDS AND LANDMARKS

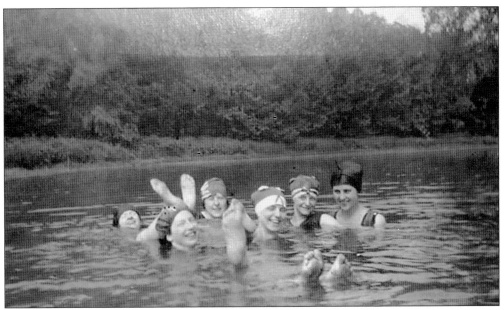

BUFFALO CREEK, 1920–1922. Buffalo Creek has been a valuable resource since the original settlers moved into the area. Some of the foundation stones for the town buildings came from the creek, and Alexander Campbell used to baptize members of his flock in the same water. Campbell's printing office was deliberately located near Buffalo Creek so that the printing paper could be dipped into the creek and then laid upon the rocks along the shore to dry. It has been utilized by Bethany College students for regattas, ice skating, tug-of-war contests, canoeing, and swimming.

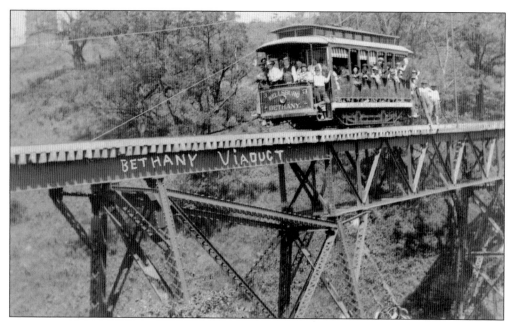

BETHANY VIADUCT, 1910. This viaduct sat on the old Coal Bowl parallel to Route 67. There were three tollhouses on the Wellsburg-Bethany Turnpike, including the first bridge coming out of Wellsburg, one beyond the second tunnel (near the halfway house), and one near the entrance of Point Breeze at the intersection of Route 67 and Route 88. The tolls were 3¢ for someone on horseback, 5¢ for a single rig, and 10¢ for a double rig.

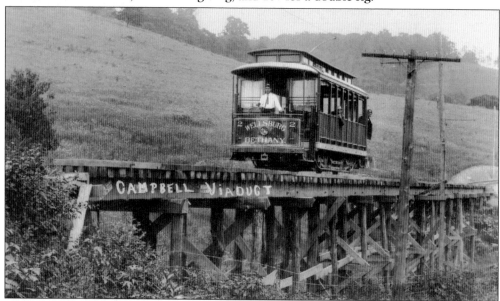

CAMPBELL VIADUCT, 1910. This wooden viaduct ran parallel between Nancy Huff's house and Point Breeze mansion. Archival records list four viaducts running through Bethany: the Bethany, Ghost Hollow, Wellsburg, and Campbell Viaducts. However, some of these may be referring to the same structures, as everyone had their own nicknames for such landmarks. The "Toonerville Trolley" system was started by Will Boyd, Frank Chapman, Robert Scott, Samuel George II, and Wilbur Cramblet Sr.

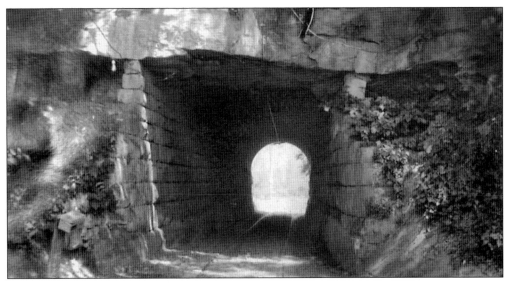

First Tunnel, 1912. The first tunnel going from Bethany to Wellsburg was the first highway turnpike tunnel constructed west of the Allegheny Mountains. It was built in 1831 by Richard Waugh at his personal expense to ease transportation to his flour mills. Four mills were constructed near Wellsburg in the 1800s. Both the first and second tunnels were torn down by the West Virginia State Road Commission in 1957. At the turn of the century a sign hung over the tunnel that said "Ying Ling Makes Good Photos." (Courtesy of the scrapbook of Elizabeth Maude Bute [Class of 1912]).

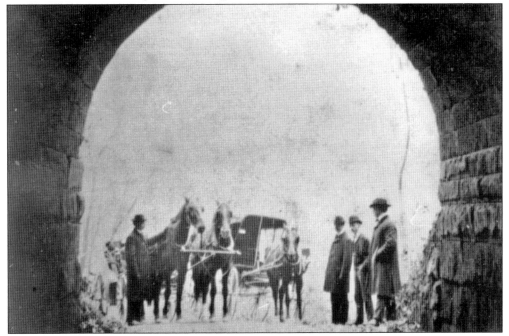

Second Tunnel, 1870s. By 1833 the second tunnel, nearer to Wellsburg, was constructed by Richard Waugh. Ironically, the only person killed inside the tunnels was Richard Waugh's son, who was hit by a trolley in the winter of 1916 and died inside the tunnel. When the state tore them down in 1957, it cost the West Virginia State Road Commission $125,000.

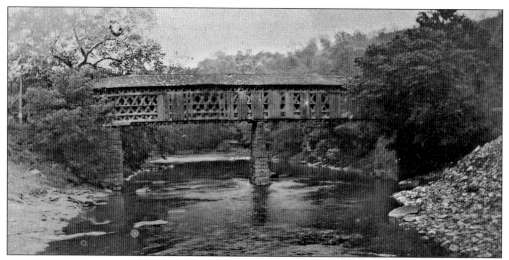

LEWIS BRIDGE, JUNE 7, 1907. Little is known about this bridge other than that it was built in 1835 and sat between Bethany and Wellsburg. There were several bridges around Bethany, including a covered bridge and a swinging bridge. The swinging expanse was used by students to take their sweethearts on long romantic walks on Sunday afternoons.

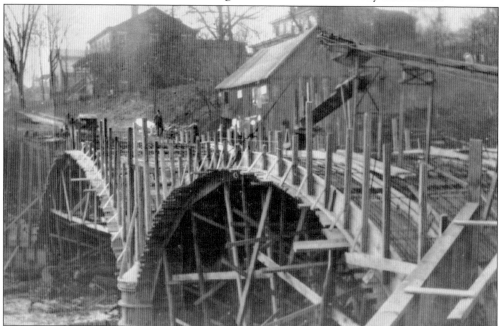

WOODEN BRIDGE, 1856–1873. Originally, area residents crossed Buffalo Creek at this spot using stepping stones. During Alexander Campbell's lifetime, there was a wooden bridge here, followed by an iron expanse in 1873 and a stone one in 1917; today there is a modern concrete and steel bridge that was built in 1988. It is popularly called the KD Bridge because the Kappa Delta sorority women lived in nearby Hibernia from 1923 to 1935. Jefferson Davis crossed the bridge here when he visited Alexander Campbell in 1842. He was so impressed with Campbell and his college that he left his nephew, W.J. Stamps, behind to study. In the winter of 1843, Mr. Stamps was ice skating near the bridge when he slipped and cracked his head; he died shortly after.

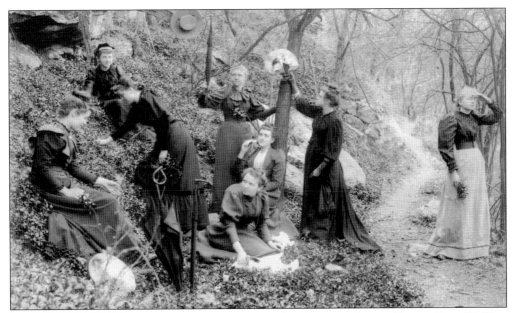

BETA WALK, MAY 1893. The hand-written note on the photograph says "Sumus Populi" (Our Fables). The Beta Walk winds off the north end of Pendleton Street and ends near Buffalo Creek. These women might be some of the many who wrote fondly of the Beta Walk at the turn of the century. It appears to be a place where students could leave the rigors of schoolwork and the etiquette required by faculty.

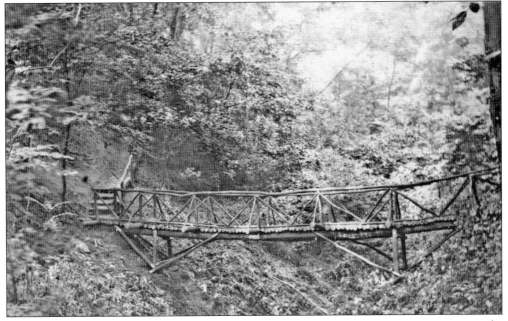

BETHANY TRAILS, 1929. Bethany is blessed with numerous picturesque nature trails. The bridge in the photograph was located on Weimer Trail, which was named after Bernal Robinson Weimer. In 1930, Weimer renovated the trails that ran through the Parkinson Woods. Professor Weimer labeled every single tree on campus and spent his spare time writing biology textbooks.

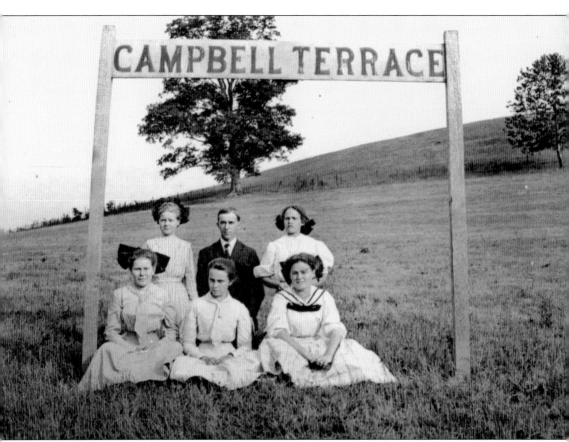

CAMPBELL TERRACE. These young Bethanians are sitting at the intersection of Route 67 and Castleman Run near the future site of the John Huff (later Randall Gorby) house. In May 1968, Randall Gorby's house exploded. Later it was learned that he was the target of an assassination plot by a member of a religious group. Apparently, Gorby had information about a murder investigation. He survived the attack but had to enter the witness protection program. (Courtesy of Ann and Hollis Craft.)

Five

GREEKS

ZETA GIRLS AND GOAT, 1912. Upsilon Alpha Epsilon was founded as a local sorority in 1902–1903 and became a national order known as Theta Chapter of Zeta Tau Alpha on June 5, 1903. Zeta was the second national sorority on Bethany campus. This photograph comes from the scrapbook of Elizabeth Maude Bute (Zeta, Class of 1912). They are smiling and at the same time appear to be admonishing the goat to mind his manners.

MYSTIC SEVEN, 1892–1893. These members of Beta Theta Pi called themselves "The Mystic Seven." They are standing on the steps of Sycamore Hall, which today is known as Hibernia. The men are identified as Billingsley, Professor Warren, Woolery, Creighton, Warren, and Prewitt. Their chant was: "Ril ral Ril ral/Ril ral faugh. Mystic Seven of Sycamore Hall." Bethany College has had a total of 32 Greek organizations.

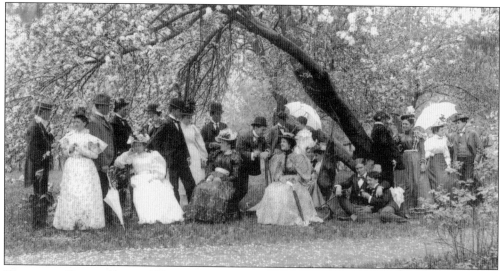

UNDER THE CHERRY TREES, 1897–1898. The brothers of Beta Theta Pi and their girls are probably "out on biz" on a Sunday afternoon. "Out on biz" was a colloquial term for dating coined in the 18th century and used at least until World War II. The Psi Chapter of Beta Theta Pi was founded on December 8, 1860. It was said to have been the oldest fraternity of continuous existence on campus until it closed on February 5, 2003. Notice the parasols, bonnets, canes, bowler hats, and starched collars. Years later, Beta Theta Pi was entered into the Guinness Book of World Records for playing the longest continuous basketball game. It took 75 hours and raised money for the St. Vincent's Children's Home in Wheeling.

DELTA TAU DELTA HOUSE, 1890s. Notice the Union Civil War caps, bowler hats, militia uniforms with paper collars and epaulettes, boating hats, and top hat worn in this photograph. The brothers are standing on the back side of the house. The shape of the Delta House has changed several times. Delta Tau Delta must have been an extremely popular fraternity, as there are 40 "Delts" in this photograph and the total student body average in the early 1890s was around 170 students.

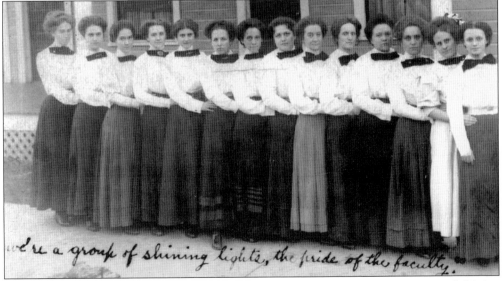

"SHINING LIGHTS," 1910. The writing on this postcard read: "Oh, we're a group of shining lights, the pride of the faculty." These girls from the Alpha Xi Delta sorority are in front of their chapter house and are wearing pins on the black horizontal bows. The girls are identified from left to right as Juanita Greer, Mary Lewis, Letha Madden, Hazel Hanna, Fern Hanna, Garda Bachell, Elizabeth Gates, Hazel Merle Mercer, Mildred Madge Stewart, Phoebe Ruth McCannon, Retta Clark, Janna ?, Edith Zoe Mercer, and Mary Cornett.

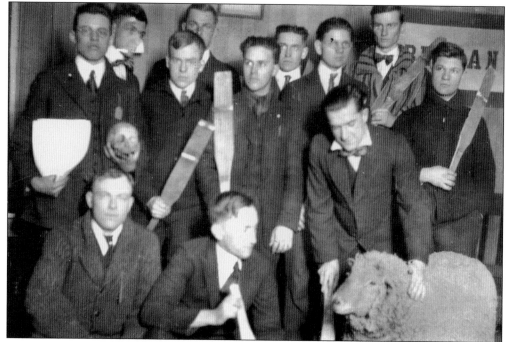

RECHABITE INITIATION, 1921. The Rechabite Club was founded as a social organization on September 1, 1910. It received its charter as the Phi Chapter of Phi Kappa Tau in 1923. These 12 Rechabites are performing an initiation service that involves paddles, skulls, bow ties, and a sheep. (Courtesy of the scrapbook of Harry Ernest Martin.)

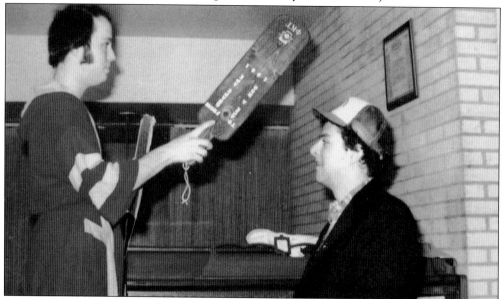

PHI KAPPA TAU INITIATION, 1980–1981. The caption in Phi Kappa Tau's scrapbook reads: "Paddling Little Brother. Big Brother Paul Raub receives his paddle from little brother. . . . I dub thee Father/Brother . . . Gary Bischof during the Hell Night." The pledge master for these proceedings was Gary Bergman. This fraternity was founded in 1923 and remains active today.

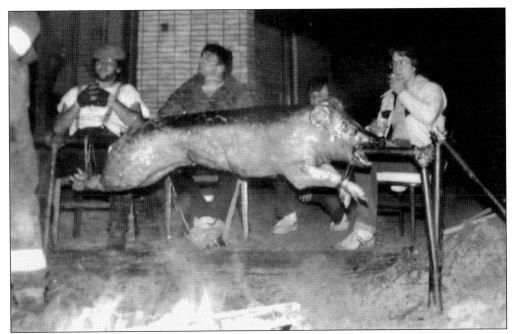

PHI KAPPA TAU'S PIG ROAST, 1980–1981. Dr. Buckelew gave the fraternity the idea for the pig roast in the late 1970s. The brothers always tried to use traditional methods except for once in the 1990s when they created a papier-mâché pig. They had this roast in front of their chapter house, which sits on New Parkinson. The tradition has not been practiced in the last few years.

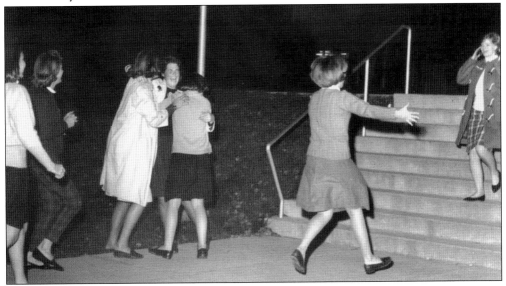

BID DAY, 1967. Bid Day is when the girls discover if they have been selected to join their favorite sorority. A representative meets with the Pan-Hellenic Council and then is notified as to who has made the cut. The girl on the right appears to be screaming with joy as she runs into the outstretched arms of her new "big sister." She is running down the steps from the quad towards Morlan Hall, which was a girl's dormitory. All of the sisters are wearing penny loafers.

45

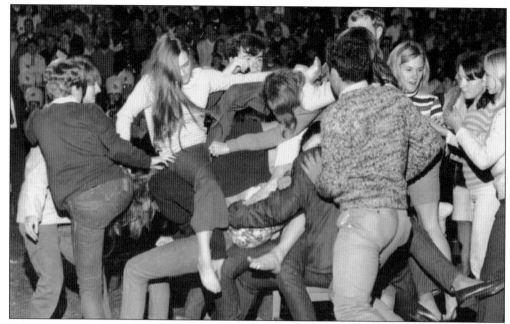

"HOW MANY CAN WE SIT?" BID DAY, 1970. This competition was held on Bid Day when the different Greek organizations compete in unusual activities, including drinking contests, initiation ceremonies, and the receiving of their pledge pins. This sorority had to see how many people they could fit on one chair. Later there was some drinking followed by more drinking.

GREEK MUSCLE, 1991–1992. These Alpha Sigma Phi brothers are keeping with the time-honored tradition of the toga party. The brothers are, from left to right, junior Erich Campbell and sophomores Jason Cudniff and Nick Kapral. They are posing inside their chapter house at Point Breeze. (Courtesy of George Williams.)

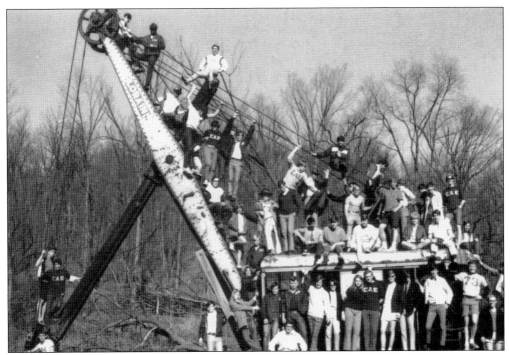

Sigma Alpha Epsilon, 1970. The brothers are photographed on a crane, possibly down in the Coal Bowl. This fraternity was founded in 1902.

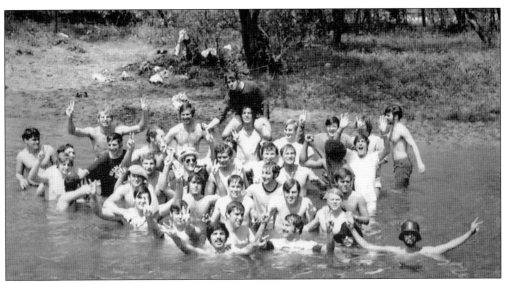

Greeks in a Creek, 1970. These Sigma Nu boys, playing in Buffalo Creek, are listed as Denny Guappone, "Bevo" Checce, Jim Duff, Jeff Mott, Chuck Sheppard, Don Waugaman, Pat Mauro, "Duke" Yearsley, Dan Swickard, Paul Caceci, Greg Stoltz, Paige Lyons, Bill Taczak, Jerry Little, Rich Gunsurich, Bill Ehrlick, Ron Villani, Marty Marinoff, Bevan Dupre, Ray Coger, Chuck Carpetta, Joe Palo, John Sompsky, Mike Gomes, Chuck Stout, Mel Hill, Dan Vincenzo, Lonnie Chavez, Paul Krosey, John Devlin, "Buzz" Katopes, Greg Smith, Al Dean, Jack Denslow, Gary Hyde, and Tom Pusteria.

Phi Mu, 1970. The girls listed as included here are M. Cook, Lonnie Goldthrope, Arlene Zatulove, Elaine Anderson, Pam Wiggans, Sue Atkinson, Sam, Barb Hoagland, Jane Goodrich, Debbie Martin, Janet Pond, Fritz Newman, Chalmers Nee, Becky Clay, Pat Browder, Sue Gibbony, Sue Meehan, Kathy Budzak, Marty Griffith, and Peggy Akers. The mission statement for Phi Mu is, "One of the oldest college women's organizations continues a tradition of excellence for today's women."

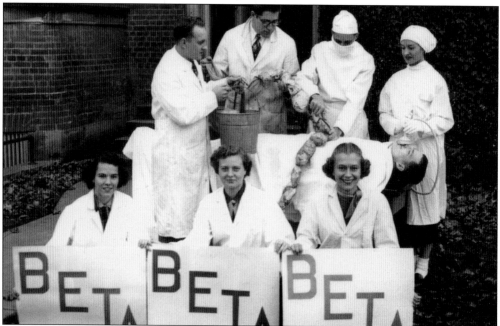

Beta Operation, 1950s. Beta Beta Beta is an honorary biology society and is seen here conducting a mock operation during Greek Week. Bethany College has had many honorary and literary societies in its history. The first societies were literary groups, including Adelphian Society (1852), American Literary Institute (1841), D'Ossolian Literary Society (1880), and Neotrophian Literary Society (1841).

Six

ARTS

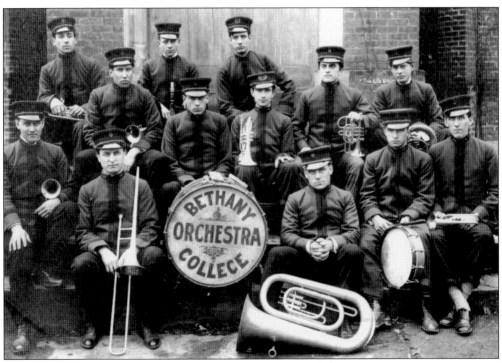

BETHANY ORCHESTRAL BAND, 1906. The Bethany orchestral band is sitting on the steps of Old Main. The group was formed on November 22, 1904, through the strenuous efforts of L.W. Barclay and several musicians. They met and practiced at the home of E.C. Jobes. The first concert was on May 12, 1905, and Ed Sullivan of Steubenville led the band. Mr. Frank Main, one of the trustees of the college, bought the band uniforms.

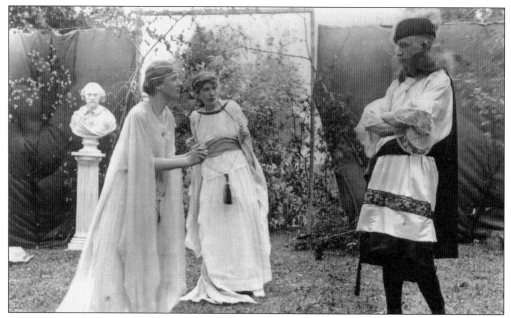

AS YOU LIKE IT, JUNE 1916. A Shakespearian play was usually performed during Commencement Week. This one appears to be in front of Old Main. Such performances were a link to the past, when the students at Buffaloe Seminary used to focus on a classical education. Notice the beautiful costumes and the makeshift theater curtain hung behind the actors. The bust of Shakespeare on the left side of the photograph remained in the theater department until at least the 1950s.

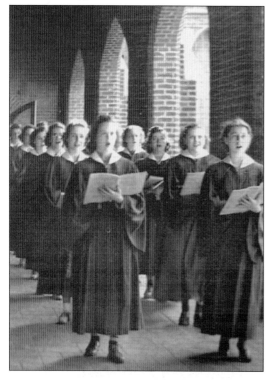

CHOIR IN CORRIDOR, LATE 1940s. The Girl's Choir often made good use of the corridor as they sang while they strolled. They usually sang Bethany songs such as "The Banks of the Old Buffalo," "The Bell Song," "On, Old Bethany," "On the Corridor," and "Bethany, My Bethany." These songs were made into a record set in 1948 and featuring the Mellowmen Quartet, Bill Reeve, and Nelson Eddy. The lyrics to "On the Corridor" include, "Marching once again on the old Corridor, We are singing gaily singing, all the songs we have sung before."

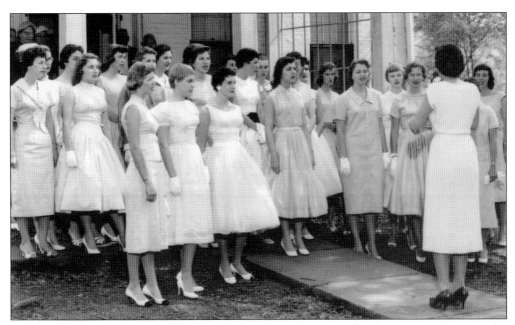

GREEK SING, MOTHER'S DAY, 1958. The Greek organizations sang for the parents who came for one weekend in the fall and spring to check up on their offspring. The groups were judged at the end of the weekend. The singers used to dress more formally, but by the 1990s the attire had grown more casual. During that decade one fraternity dressed in boxers and one boy threatened to "moon" the audience. These girls from Alpha Xi Delta would never have done such a thing in their white gloves, pumps, and dresses.

"OSCAR & HOUDINI," MAY 10–13, 1979. Oscar winner Fran McDormand and David "Houdini" Hoseini are seen here in *A Little Night Music*; David Jones Judy and William P. Crosbie directed Steven Sondheim's evocative play. Dr. Judy was the backbone of Bethany's theater program for many years. Fran was involved in many theater projects at Bethany College and did some directing at Wheeling's Towngate Theater during the summer.

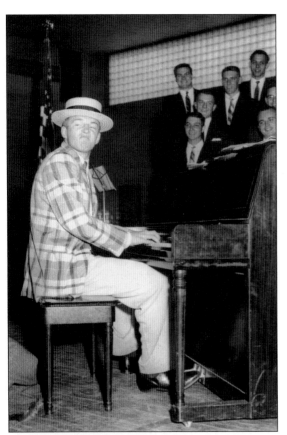

RAGTIME, 1956. Bethany student Hugh Edward "Ed" Joyce (Class of 1958) is on stage with the male choir. Hugh was a public relations major, a member of the football squad, in the economics club, and a part of Sigma Nu. After graduation he became president of the James River Air Conditioning Company in Beaverdam, Virginia.

BELL CHOIR, 1967. Mrs. Aleece Gresham, seated center, is directing the bell choir practice at Highland Hearth, which served as President Gresham's home. The group frequently put on lively demonstrations for visiting guests and for Gresham family and friends. They also could be seen regularly at the Bethany Memorial Church.

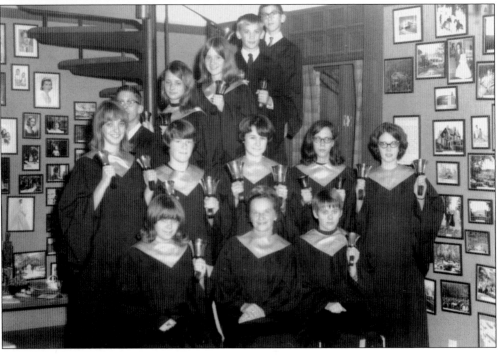

KING LOUIS, OCTOBER 1967.
John Taylor, shown here as
King Louis in *Beckett*, is a popular
professor of English. The Bethany
production of Beckett was
directed by John Lewinger, and
Jean Anouilh was the playwright.

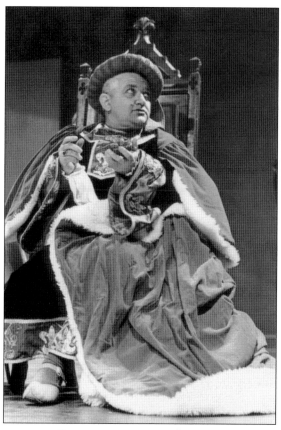

ROYAL HUNT OF THE SUN, 1970.
Large theater productions like this
one were usually performed in
Steinman Hall. The David B. and
Irene Steinman Hall of Fine Arts
was dedicated in September 1969.
Theater productions continue to be
performed there, as well as special
events sponsored by the Renner
Union Programming Board, including
Chinese acrobats, magicians, and the
mentalist Craig Karges. This play was
performed in the Wailes Theater.

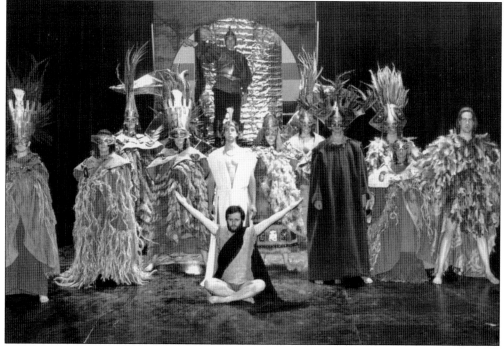

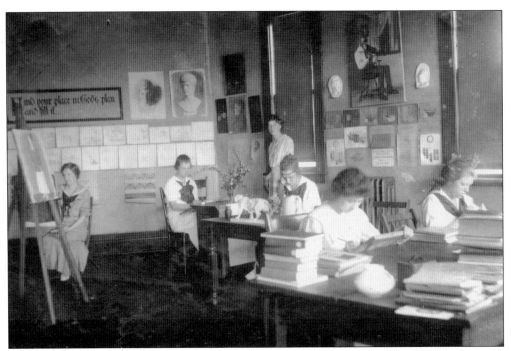

ART CLASS, 1916. The freshmen women identified are Jennie Steindorf, Ursala Yeakel, Nellie Ash, and Gladys Williams. Notice the sign on the back wall that reads, "Find your place in God's plan and fill it."

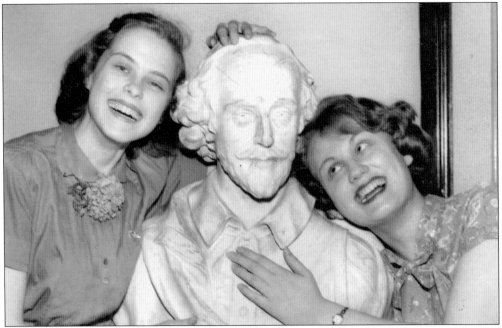

THE BARD'S GIRLS, 1955. English majors Jane Mobely and Jean Weser are flirting with a bust of Shakespeare in the hopes that their grades will improve. This statue is also in a 1921 photo on page 50. The Bethany Bard's "noggin" is now missing but the tradition of studying the classics is still present. Notice the graffiti on Shakespeare's forehead.

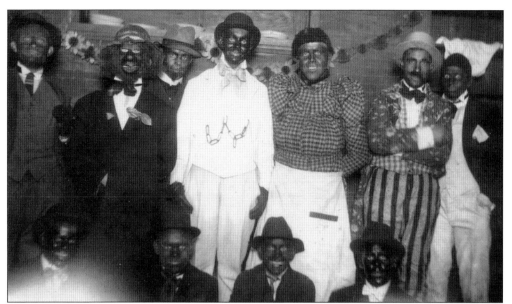

Minstrel Show, 1921. Minstrel shows were quite popular forms of entertainment in the first half of the 20th century but are now viewed negatively. Among the 11 students are Thomas R. Egbert, ? Bird, ? Fry, ? Shively, ? Moore, and Charles E. Welch. One student is wearing chains, one is dressed as a circus ringmaster, and one is in a dress. The first appearance of the minstrel troupe at Bethany College was under the direction of the glee club in April 1891. (Courtesy of the scrapbook of Harry Ernest Martin.)

Bethany College Glee Club, 1893–1894. Glee clubs were very popular choral groups and were similar to the German singing societies of the 19th century. In 1890, students organized a glee club with 12 members. Mr. Garrison was the first director and Mr. Jenkins acted as secretary and treasurer. There was also a Bethany College mandolin and glee club.

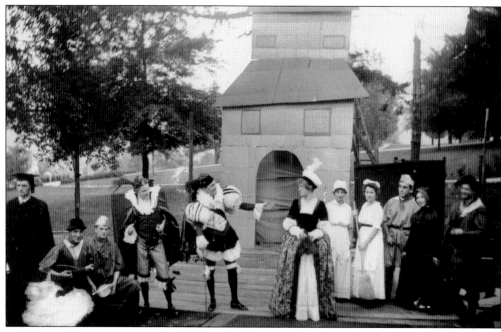

GRAND DRAMA, 1921. This bizarre production appears to be a farce. Notice the mandolin, maid outfits, Renaissance costumes, widow's wear, and cap-and-gown. Bethany College has seen many grand productions, including vaudeville shows and Gilbert & Sullivan's *The Mikado*. (Courtesy of the 1921 scrapbook of Harry Ernest Martin.)

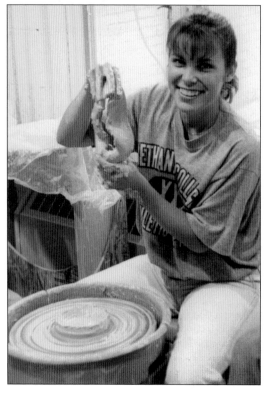

THE POTTERY WHEEL, 1995. This photograph was taken by a student in Prof. Jon C. Gordon's photography class. The caption read, "Showing off her best pot yet is senior Robin Evans. Herb is sure to like this one." Professor Gordon was a popular member of the faculty from 1991–1999. Herb Weaver has continued the strong tradition of ceramics at Bethany. His monkey sculpture, entitled *The Peacefulness of Primates* in front of the library, attests to his creativity.

THE EAGLE SPREADING HIMSELF.

"Pro Bono Publico, Pro Bono Calico."

TWENTY-SEVENTH COMMENCEMENT

OF

BETHANY COLLEGE,

Thursday, June 18th 1868.

MARSHALS:

Prof. JOTHAM ASINUS WILLIAMS. Prof. JANE GULLIVER HAWLE

REVERENDUM GULIELMUS REX PENDLETON, D. D., P. B.

COLLEGII BETHANIENSIS

PRÆSIDEM

CUM OMNIBUS PROFESSORIBUS TUTORIBUSQUE.

HONORANDUM EJUSDEM CURATORES.

VENERANDOS ECCLESIARUM PASTORES.

UNIVERSOS DENIQUE UBIQUE TERRARUM HUMANITATIS CULTORES

HI JUVENES ARTIBUS INITIATI.

BOWLEGGED LUCIFER COLEMAN,
JEREMIAH WORTHLESS CRENSHAW,
GAS BAG CROW,
REBECCA COURTNEY,
JACK LUPUS DARSIE,
GREEN WEASEL DARSIE,
JEEMES HYPOCRITE DODD,
BONE BREAKER FERGUSON.

WILK ODOROUS FOLEY,
BOOBY TRICKSTER JONES,
GRAVE BABY NELSON,
WOOD PECKER NEALE,
GUMPY TWIST OLIVER,
STEWED CABBAGE ROBINSON,
JOCKEY MONKEY STREATOR,
WOODEN HEADED SCHELL.

Octavus decimus Junii Anno Humanæ Salutis MDCCCLXVIII.

Reipublicæque Americanæ XCIII.

SALUTANT.

"THE BODACIOUS SPECTACLE" JUNE 18, 1868. This commencement program was tongue-in-cheek. The students made up songs such as "The Day I Broke Jail," "Moses in the Bulrushes," "Viewed from a Physicalologomolical Standpoint," and "The Posthumous Flame of Light Gymnastics." They also created stage names for themselves, including Bowlegged Lucifer Coleman, Jeemes Hypocrite Dodd, Wooden Headed Schell, and Jack Lupus Darsie. They commented that their production was "the bodacious spectacle."

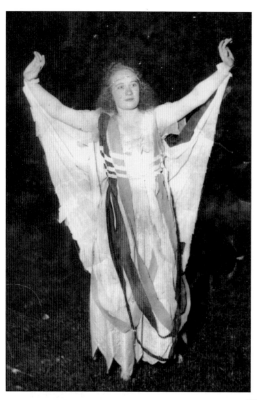

MAY DAY DANCE, 1921.
Mary Evegeline Helfry (Class of 1921)
appears to be in a trance as she sways
across the lawn. She is probably a part of
the May Day celebrations held that year
at Bethany College. The ribbons around
her resemble those worn by that year's
maypole dancers. (Courtesy of the 1921
scrapbook of Harry Ernest Martin.)

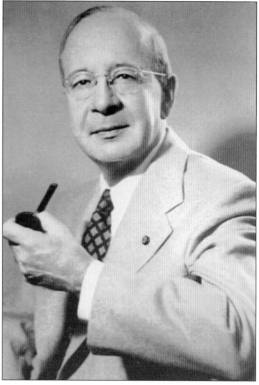

**DAVID BARNARD STEINMAN, POET AND BRIDGE
BUILDER.** In 1960 David B. Steinman
donated $10,000 to establish the annual
Steinman Poetry Lectures, which brought
famous poets such as Mark Van Doren,
Archibald MacLeish, and Allen Ginsberg
to Bethany. Steinman designed and built
more than 400 bridges on 5 continents,
authored 24 books, wrote 5 anthologies
and 600 professional articles, and had
more than 150 poems published in
prominent poetry magazines. One of his
most famous projects was Michigan's
Mackinac Straits Bridge. The Steinman
Fine Arts Center was named in his honor.

Seven

SPORTS

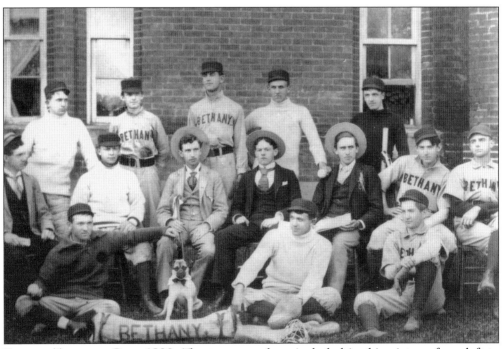

BASEBALL TEAM WITH DOG, 1893. The team members included in this picture, from left to right, are listed on the photograph as (front row) Wilhelm, Darsie, and Morris; (middle row) Townsend (umpire), Allen, Brendenberg, H. Vodrey (manager), M.M. Scott, Bell, and Carey; (back row) G.D. Lovett, E.W. McDiarmid, Turner, Lewis, and C.M. Watson. Notice the dog mascot and the flimsy catcher's mask. Bethany had indoor baseball as early as January 1935.

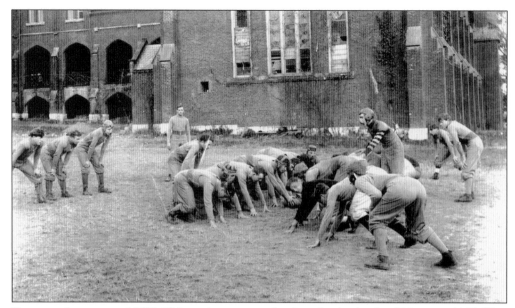

FOOTBALL SCRIMMAGE, 1907. This scrimmage took place in the back of Norman A. Phillips Dormitory for Men (Commencement Hall). Notice that several of the windows are broken out of the dormitory. Look carefully at the linebacker with the striped sleeves. He is wearing an old-fashioned nose guard, which covered only the nose and teeth. The offensive center is wearing a leather "helmet" that appears to cover very little. The quarterback has no facial protection.

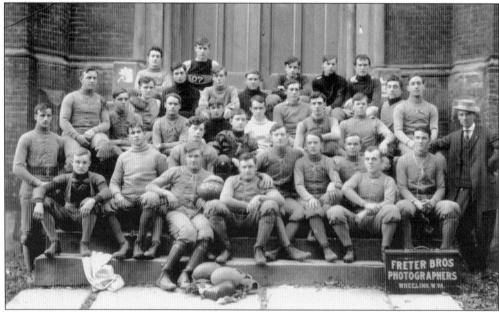

FOOTBALL, 1907. Pictured from left to right are (front row) Yancy, Bevan, Jarrett, Chapman, Oight, W. Linville, Uhle, Mercer, Smith, Marshall, and Casey (manager); (middle row) Filson, J. Chapman, "Ice," Kemp, Murray, Carfer, Potter, Bailey, Davies, McEvoy, Lewis, and Woolery; (back row) Bower, Pryor, Bamboorgh, Aiken, Henley, Carter, Haverfield, Hill, and Johnson. Notice the tie-up shirts and the stitched-in thigh pads.

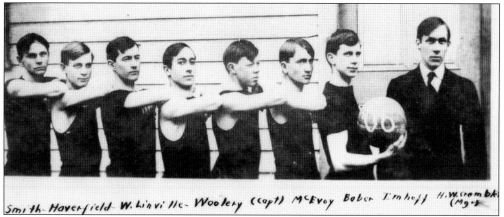

Smith Haverfield W. Linville Woolery (capt) McEvoy Bober Imhoff H.W.Crombk (Mg·r)

BASKETBALL, 1906. This is the earliest photo in the collection showing Bethany's basketball team, which started at Bethany in 1905. The first inter-collegiate competition was held in the old gymnasium. There was no space for out-of-bounds and students had to stand on a balcony or balance on braces that held the exercise equipment. In October 2002, Coach Aaron Hoffman became the 23rd head basketball coach. Bethany won the PAC Championship in 1962, 1964, 1966, 1967, 1968, 1978, 1982, 2001, and 2002.

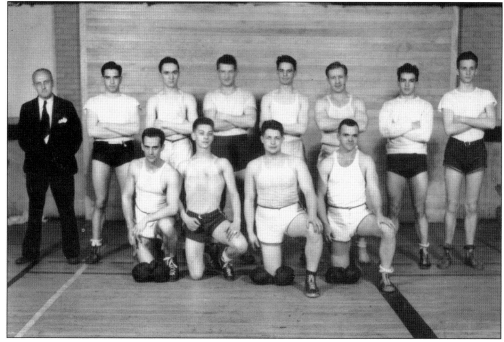

BOXING CLUB, 1920. Members of this club are probably standing in the Irvin Gymnasium. The group looks very rough-and-ready except for the short shorts. Notice the boxing gloves in front of the first row. The coach on the left does not appear to want to have his picture taken.

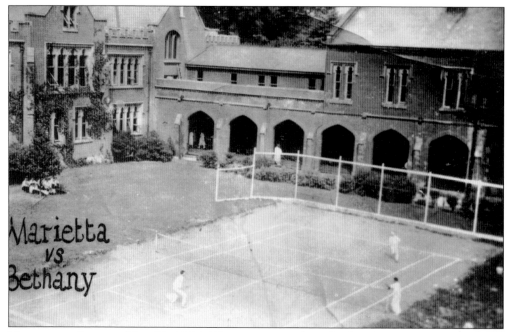

MARIETTA VS. BETHANY, MAY 13, 1921. This tennis match took place behind Old Main where outdoor commencements now take place. It must have been a hot day because all of the spectators are crouched under the small tree.

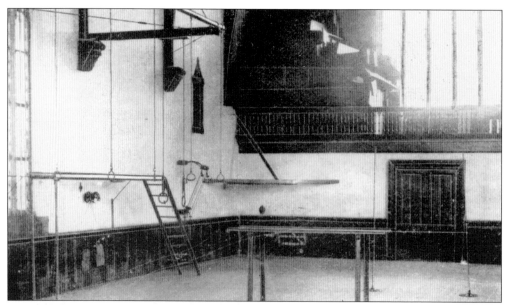

COMMENCEMENT HALL GYMNASIUM, 1890–1903. Commencement Hall was used as a gymnasium between 1890 and 1903. The Gothic windows in the back face where T.W. Phillips Memorial Library now stands. The stained glass windows are not original. The hammer-beam truss style was copied from the House of Commons in London, England. The sloped stones under the carved polished walnut beams were removed to add a second floor in 1903. Notice the old-style exercise equipment including the parallel bars, punching bag, and iron rings.

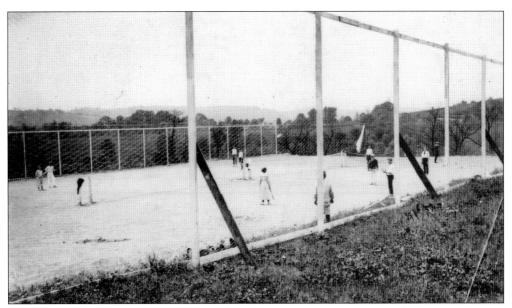

Tennis Courts, 1921. These courts were located where Morlan Hall (1964) now sits. Early in the history of the college, this area was a clay pit where the bricks used to build the college were formed and fired. Notice the man wearing a tie during his match and another man wearing a beret. At the First Annual Field Day at Bethany College, held on June 17, 1890, the ladies held a tennis contest at 2 p.m.

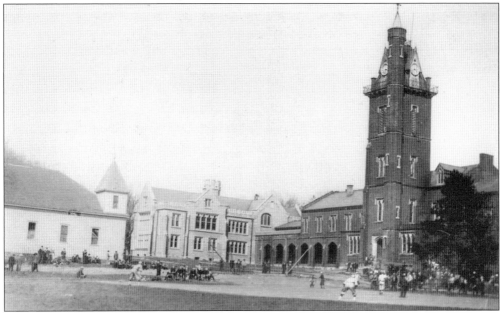

Baseball behind Old Main, 1910. The photographer was probably standing where the entrance to Richardson Hall of Science now sits. Many sports were played here until 1939, including baseball, football, field hockey, track and field, archery, and tennis. The building on the far left was a gymnasium and was burned by an arsonist in 1915. A few days later a small fire was discovered under the Old Meeting House, but it was dowsed in time. The arsonist was never caught.

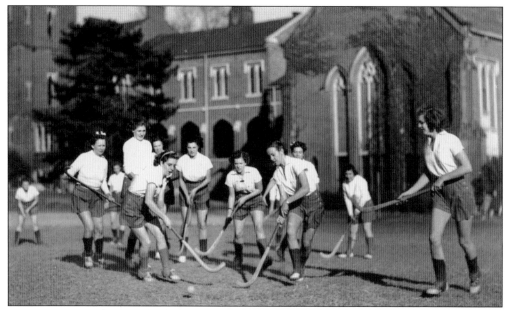

FIELD HOCKEY, 1940. Notice the saddle shoes, the stirrups on their stockings, and how much shorter the skirts have become since the 1921 tennis court photograph on the previous page. By 1940, Commencement Hall was covered with ivy. The Bethany College field hockey team won the PAC Championship in 1985. Field hockey was played at least as early as the 1930s at Bethany College.

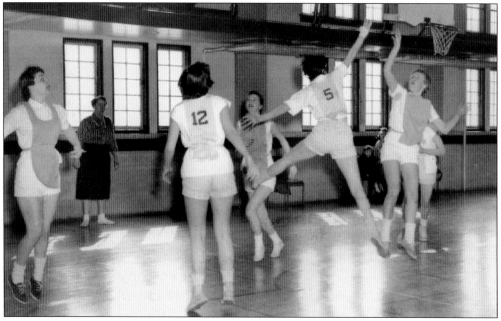

JUMP SHOT, 1958. The girls basketball team was wearing "dickeys" during their match. This contest was held in Irvin Gymnasium, which had a small second story overhang for spectators. Irvin Gymnasium was completed in 1919. The girls used Irvin Gym from 1948–1975. The student wearing the No. 12 jersey appears to be sporting Chuck Taylor Converse All-Star high tops.

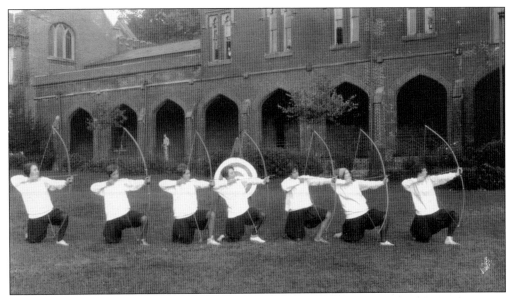

ARCHERY, 1930. The girls are shooting at circular targets behind Old Main. "Token" programs for women existed in baseball, basketball, swimming, tennis, and track until they nearly came to a close in 1925. The Women's Athletic Association reorganized at Bethany College in 1933–1934 when Virginia Hemington and Katherine Hope protested over the partiality towards men. However, girls' sports did not appear in a yearbook until 1973. Notice the sweatshirts and split-skirts.

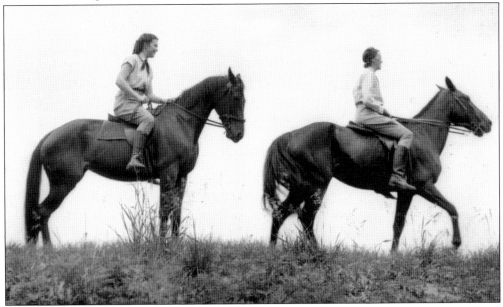

BETHANY EQUESTRIANS, SEPTEMBER 1938. Miss Virginia Forsythe and Mrs. Neil Graham are on the bridle path and nature trails in Bethany. In 1939, two new horses were added to the Bethany Stables at Point Breeze. One was a Western riding pony, a spirited but well-mannered mount. The Bethany College Riding Academy was very popular with students and faculty. A new equestrian center is being built on Peace Point by Gene Valentine and should be ready by fall of 2004.

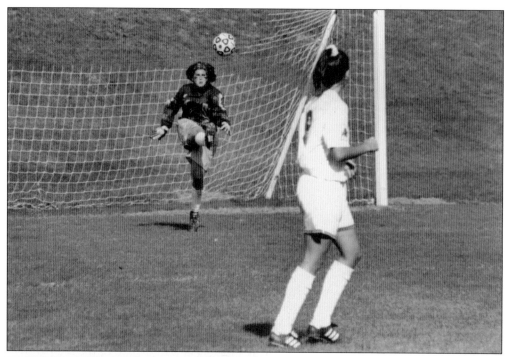

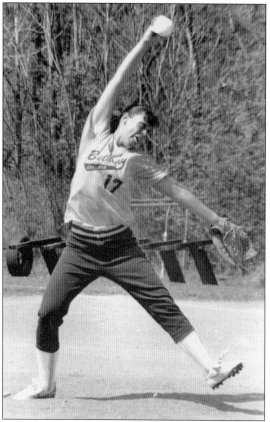

A BETHANY SAVE, 1994. The caption in the 1994 yearbook reads, "Sophomore goalkeeper Kristen McCreanor comes out of the net kicking on the Bison's home field." Frankie Taal (1998) is in his second year as Bethany College's women's head soccer coach. He was a member of Bethany's 1994 NCAA Division III championship team. The women's soccer team won the PAC Championship in 1991–1994 and 1999. (Courtesy of Todd Ollinger.)

THE WINDUP, 1989. This snapshot was taken by the college photographer, Dana Garner. The pitcher appears to be Lyn Alderson. In 1989 she was named the Most Valuable Pitcher in the conference. The Bethany College softball team originated in 1980 and finished sixth in the 2002 NCAA World Series. They have produced three All-Americans: Amy Shafer, Rachael Burns, and Raquel Burns.

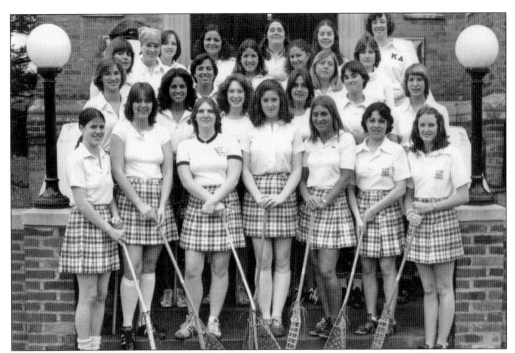

LACROSSE, JULY 7, 1978. Coach Sally Dorwart is standing at the far right of the second row. She coached both field hockey and lacrosse for several years and was a member of the faculty from 1977 to 1982; Sally served as a mentor and friend to many of her athletes. Women's lacrosse is no longer played as a varsity sport at Bethany College, but the men still have a lacrosse club.

RUGBY, 1990s. Bethany College has always had a healthy number of intramural and club teams. Today, lacrosse and rugby are club sports with devoted followings. Bethany College students have also participated in ultimate Frisbee, hiking, skiing, skydiving, white-water rafting, camping, wrestling, weight-lifting, surveying, and rock climbing to name just a few. Bethany alumnus, Troy Martin (Class of 1986) graduated cum laud and went on to become known to professional World Wrestling Federation fans as Shane Douglas, the Franchise. He was the youngest wrestler ever to win a national title (WWF Television Title) at the age of 21. His trademark move is called the "Pittsburgh Plunge."

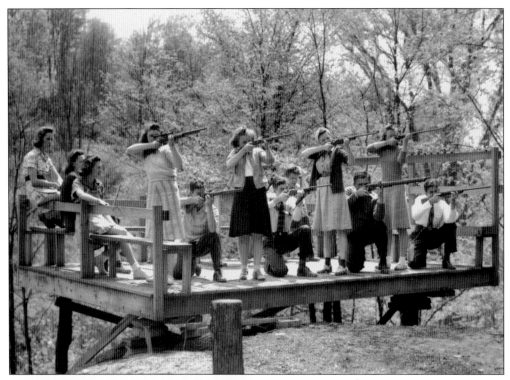

SHOOTING, 1947. Target practice was a logical program to have after World War II. Notice that the shooters are both male and female. They were perfecting their marksmanship on Rine Field, which was used for football, baseball, track, cross country, and soccer, as a rifle range and an obstacle course. This 80-acre plot of land west of campus was a memorial to Edwin M. Rine, friend and benefactor of Bethany College. Today, this is known as Bethany Field.

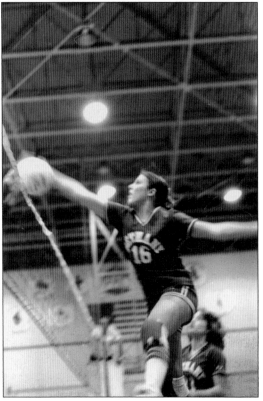

VOLLEYBALL, 1979. Sophomore Judy Montgomery is seen spiking over a Bethany opponent. In 1979 the women's volleyball team finished with an overall record of eight wins and six losses. They captured the Pennwood West Conference Championship during their 19-day season. Judy also played softball and basketball.

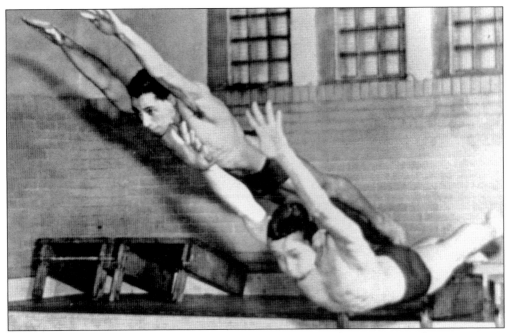

SWIMMING, 1960–1961. Dick Moffat and Bob Pace are diving into the pool in Irvin Gymnasium during a practice race. Dick was proficient in the breaststroke while Bob favored the backstroke. The swimming coach, John McGowan, is entering his 24th year as Bethany College's head swimming and diving coach. The Bethany swim team won the PAC Championship in 1967, 1968, 1969, 1970, 1971, and 1972. In 1967 Bethany College swimmers won the N.A.I.A. championship in the 400-yard relay.

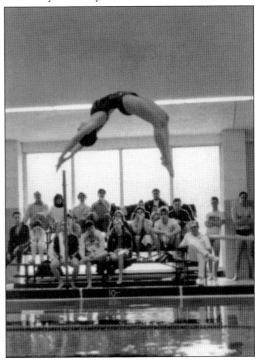

DIVING, 1987. Female diver Leigh Hocker performs her variation on a back dive. This home meet against Frostburg took place in the John J. Knight Natatorium. That year Amy Nowalk broke four conference records, and Leigh Hocker won second place in the President's Athletic Conference.

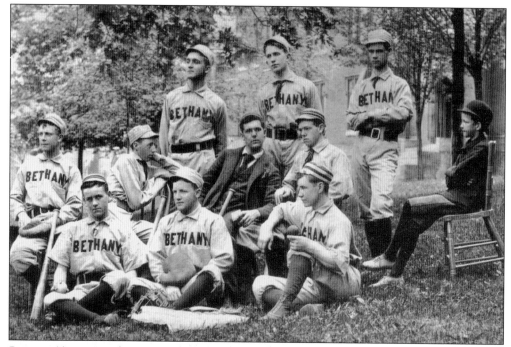

BASEBALL TEAM AND WATER BOY, 1892. The team is pictured with its water boy, who is seated on the chair. In 1994, Coach Rick Carver became the college's all-time winningest head coach. During the 1996 season Bethany College had the second-highest team batting average (.410) in NCAA Division III history.

BICYCLE KICK, SEPTEMBER 1981. This game was against Hiram College and the photograph came from the 1982 yearbook. That year, under the coaching of John Cunningham, the team went 8–4 and placed first in the President's Athletic Conference. In 1994 Bethany College won the NCAA Division III National Championship. Bethany College has also sponsored a soccer camp for 6- to 18-year-olds for 30 consecutive years.

Eight

STUDENT LIFE

GOOD CLEAN FUN, 1958. The Spring Carnival at Bethany College has always been a good time for students and faculty. The varied events have included a sorority pie-throwing event, mudslides, bathing beauty contests, and water-balloon fights. This Kappa Delta woman is being drenched by a fellow student. The annual event was sponsored by the Association of Women Students. Note the Wheeling Corrugating bucket that is being used in the event.

Moo Moo, 1921. This Guernsey cow was a part of the herd supplied by Earl Oglebay for the Bethany College Farm where there were 40 stalls and 40 stanchions; they called the farm an Agricultural and Horticultural Experiment Station. It began in 1911–1912 and ended in 1957–1958. We do not know if the Moo Moo Moo pep club got its name from this herd. (Courtesy of the scrapbook of Harry Ernest Martin.)

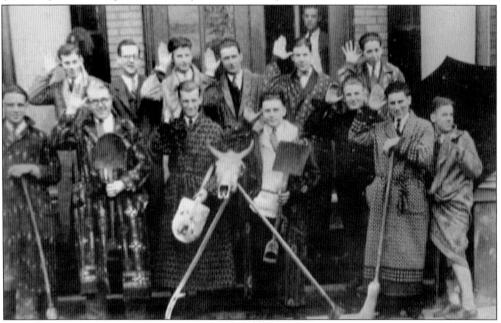

Moo Moo Moo, 1924. This honorary pep club was organized in 1923 and stirred up spirit at athletic events. The pledging freshmen were called "calves," while members were known as "bulls." The president was called "Big Bull." The dress code of a bathrobe and goofy hat predates the Delta brothers from *Animal House* by about 50 years.

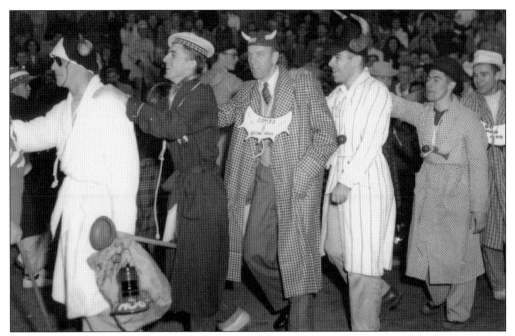

Moo Moo Moo Redux, 1953. Being initiated during homecoming weekend into Moo Moo Moo was president Perry Epler Gresham, at which time he was given the title of "Sitting Bull." The new Bethany College president's inaugural events closed with an inaugural ball in the Pine Room at Oglebay Park. An article in the December 11, 1959 issue of the *Bethany Tower* stated, "Every year with the influx of young shining faces to the campus, it is left mainly to the Moos along with the Varsity B's to channel their youthful exuberance towards school spirit."

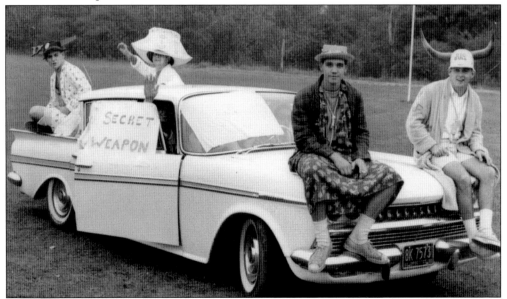

Four Moos on a Car, 1955. This homecoming parade had a strict dress code consisting of a lamp shade, bison horns, fishing hat, saw hat, and bathrobes. Events like this usually brought out not only the student body but also most of the townspeople.

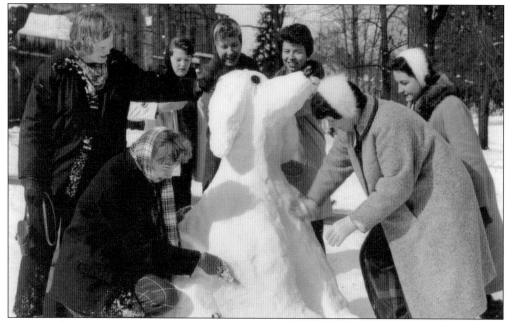

SNOW CARNIVAL, 1967. There were specific qualifications in order to have a snow carnival. It had to be a day in the spring semester when four inches of snow had fallen by 6:15 a.m. It could not take place during the fall semester, the first week of the spring semester, on a formal convocation day, or the last week before mid-term break of the spring semester. The students created sculptures in front of Old Main, including a green alligator, a surfer, a unicorn, a foil-wrapped candy kiss, a beagle, E.T., Snoopy's doghouse, Rapunzel, Moby Dick, a Cheshire cat, and Mary Poppins.

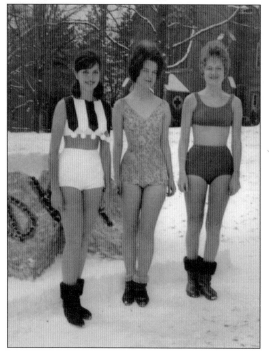

THREE SNOW BUNNIES, FEBRUARY 16, 1963. Bethany's loveliest ladies competed for the title of snow queen and court during the snow carnival. This test of will lasted at least up until the 1990s, and the guys didn't seem to mind. The names on the reverse side of the photo read, left to right, Kathleen Zisa (Queen of the Winter Carnival), Barbara Bicks, and Christie Collins. They are standing in front of Old Main. Notice the bouffant hair styles and the modest bathing suits.

PSEUDO-SLED DISTANCE RACING, 1970S. The man in the front looks petrified before his sled ride during the snow festival. Other events included snow football, shuttle races, the human snowball, "fox & cat," keg toss, sock hop, tug-of-war, target toss, human croquet, and snow soccer. There was also a long tradition of taking the trays from the cafeteria and sliding down the hill between Pendleton Heights and Steinman Hall. The faculty often would build a bonfire if the conditions were right.

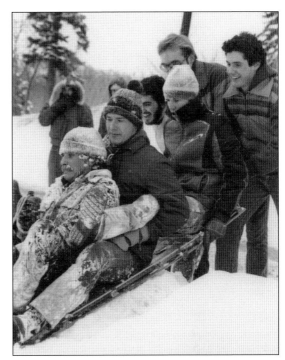

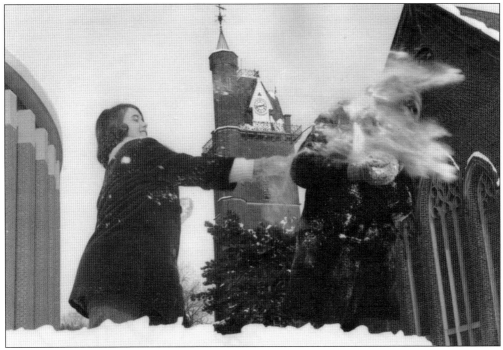

BIFF, 1966. This snowball fight occurred between Richardson Hall and Commencement Hall. Notice that the student on the right is catching one in the face. The most recent snow carnival was held on March 8, 1996. One year the students had a cabaret in the barn. The 1966 snow carnival was the sixth annual carnival. That year, most of the school's 900 students split into groups of 11 to have their sculptures judged. The winner in 1965 was Kappa Alpha.

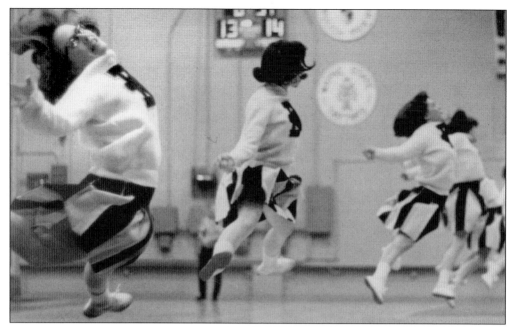

CHEERLEADERS IN ALUMNI FIELD HOUSE, 1966. Bethany College has had many non-Greek clubs and organizations, including The Merry Masquers (1914), the Agricultural Club (1912), the Nicotine Club (1911), the Barbarians (1917), the Treble Clef Club, the Pierians, and the Phandangoe Club. The Nicotine Club called itself "A Society for the Destruction of the Weed," and their aim was to "exhaust the visible supply by smoking it up." Their emblem was "coffin nails and brown finger tips." Another strange group was the Bolsheviki Club, whose motto was "When in Rome do the Romans before they do you!"

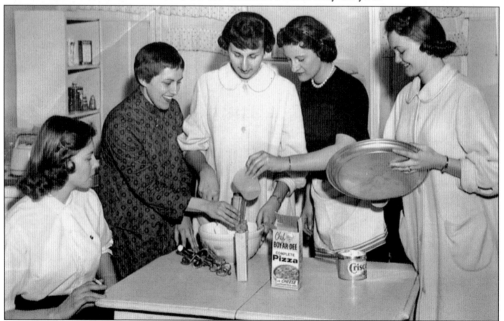

CHEF BOY-AR-DEE, 1959. These Kappa Deltas are cooking some boxed pizza in their dorm room. Notice that the girls are cooking with Crisco while wearing pearls.

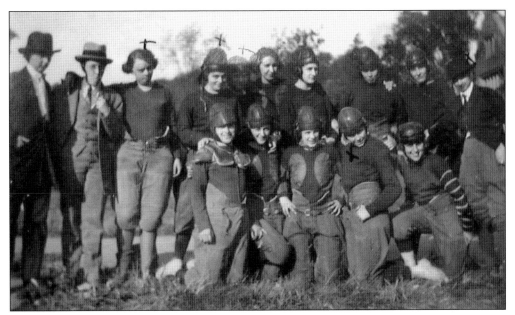

GALS MOCKING THE FOOTBALL TEAM, 1921. These 15 women are dressed up as the Bethany football team and coaches. Several old photographs show that guys and gals would play jokes on each other by putting on the clothes of the opposite sex.

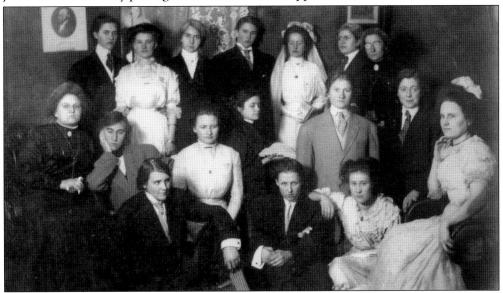

MOCK CHAPEL, 1911. This was a popular spoof of the faculty, and this particular one came from the scrapbook of Elizabeth Maude Bute. One of the plays was entitled *A Combination Circus and Animal Show*—this type of parody goes back at least to the 1860s. They had orations such as "Omne Vivum Ex Ovo—Woman is a Brick, by Big-Sorghum Snout Dean," and sang songs such as "Vale Slobberers." They created unique names for themselves including Wiggler Pollywog Aylsworth and the Crusticarboniferlous Mamruphomlia of the Muskrat Triplemmagrammatic Sandstone. The 1921 yearbook states, "the students conducted a Mock Chapel, and so cleverly did they imitate the members of the Faculty that the professors had a chance to see themselves as others saw them."

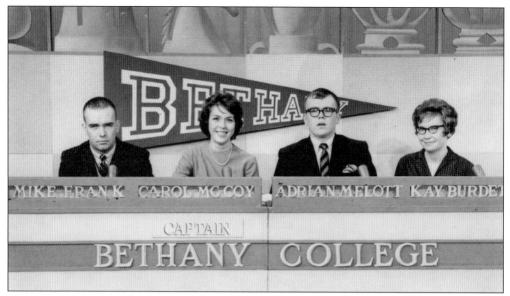

GENERAL ELECTRIC COLLEGE BOWL, APRIL 18, 1965. In 1965, Bethanians, from left to right, Mike Frank, Capt. Carol McCoy, Adrian Melott, and Kay Burdett appeared on the popular NBC television show where a moderator asked oral examinations of liberal arts academic subjects. The program bragged that they were being televised "in living color." Unfortunately, on this day Bethany was defeated by Wisconsin. The clothes on these 1960s students could be indicative of their position on the Vietnam War. In the yearbook, they either looked like the cast of *Leave It to Beaver* or the cast of *Hair*.

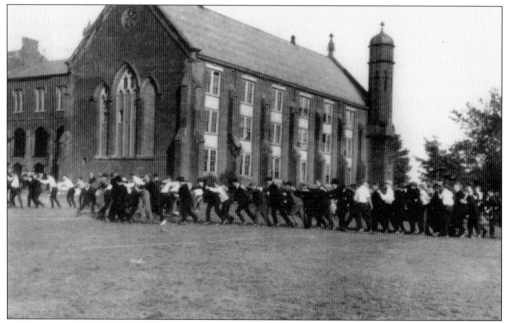

SNAKE DANCE, 1916. This Bethany College tradition was performed every time the football team scored a victory. Seen here is the snake dance winding its way through campus after a Bethany win over Salem by a score of 6–0. The dance started behind the Norman A. Phillips Dormitory for Men.

BETHANY HOUSE, 1915. The Bethany House was a boarding house located on Main Street, featuring a laundry in the basement. Notice the "pug ugly" hats on the men and the fur collars on the women. By this time in history one can see the women's ankles below their hemlines. The new Bethany House went up on this same site and has continued to be a place for students to congregate. The new building had a student union and a snack bar called the Bee Hive.

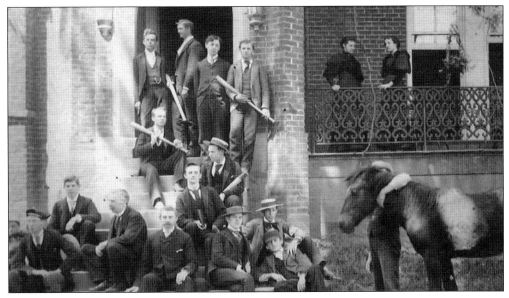

TAFFY PULL AT THE HEIGHTS, EARLY 1890s. This snapshot shows Pendleton Heights when it was a dormitory for women. Notice the guys with baseball bats, women with big black sleeves, a horse, and the handle-bar mustaches. Each female resident of the hall was, according to the 1889–1890 catalog, "expected to bring with her sheets, pillow cases, towels, napkins, napkin-rings, fork, teaspoon, and a lamp." For entertainment the ladies once put on a taffy pull. Lacking modern facilities, the women had to draw water from a rope in a well.

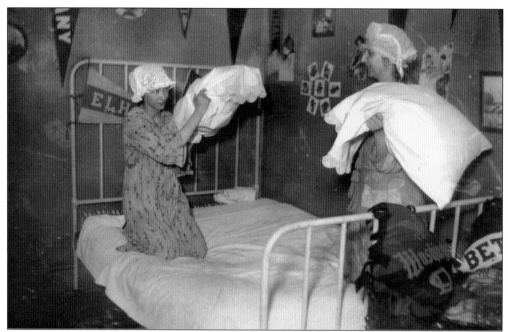

Pillow Fight, 1921. This photo of an early pillow fight came from the scrapbook of Harry Ernest Martin—notice the duster caps. This dorm room was inside Phillips Hall. The illustration on the wall might be of a Gibson Girl. Charles Dana Gibson was a famous illustrator of women's fashion whose drawings often appeared on the girls' dorm room walls.

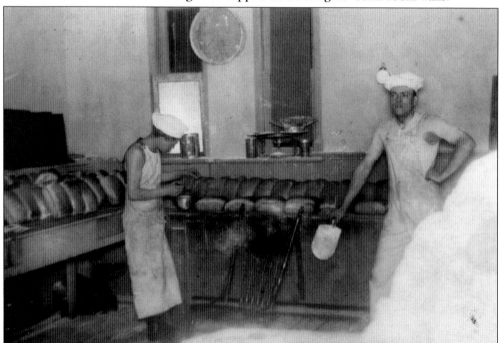

Bakery Boys, 1921. This is a photograph of Harry Ernest Martin (Class of 1921, right) and an unidentified friend. The bakery was in the basement of Phillips Hall. This was how Martin paid his way through college, along with taking photos for the college publications.

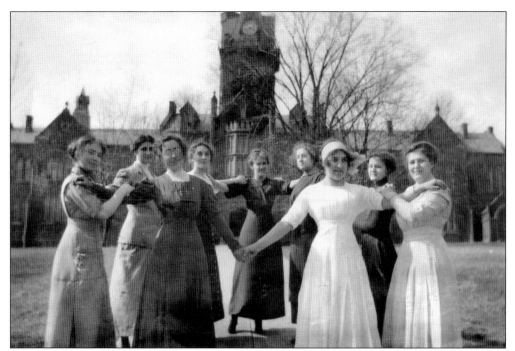

"Some of the Fair Ones at Bethany," 1912. This evocative picture comes from the scrapbook of Elizabeth Maude Bute. These women are probably from the Zeta Tau Alpha sorority and conducting an impromptu dance in front of Old Main—notice that the dresses now show the ankles. The styles were more tailored than in the 1890s and the hairstyles more natural. It is also rare to see a woman standing for a photograph wearing her glasses.

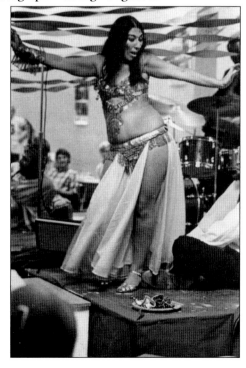

"Little Egypt," October 1970. The featured speakers included Fayez Sayegh, a member of the Kuwait delegation to the United Nations, and Zvi Brosh, Israeli Minister of Information. The principle topic was the future of the United Arab Emirates and the United States. There was also time to watch "Little Egypt" perform a belly dance.

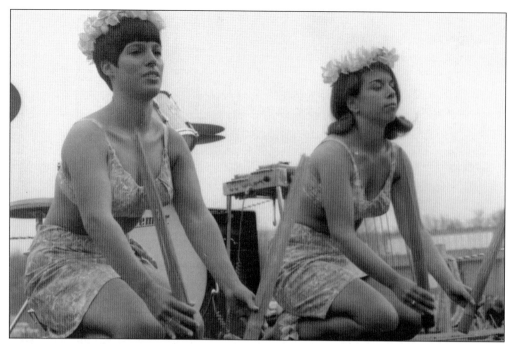

Luau Ladies, 1967. This photograph shows Barbara Cordjeris and Mary Ellen Michele performing a Hawaiian dance during Spring Carnival. This year's carnival had a Hawaiian theme that included a large earthen volcano in the Coal Bowl. Hula dancing, pineapple eating, and limbo sticks were seen.

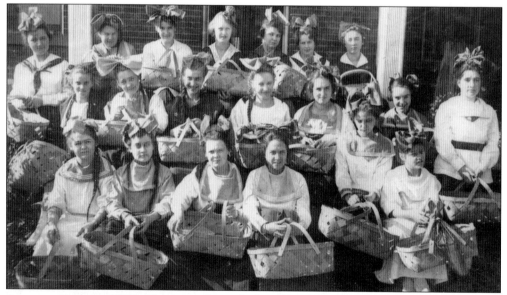

Bows and Baskets, 1921. These are the girls from the freshmen class of 1921—notice the bows and pony tails. The freshmen class had to list their hopes and dreams in a publication called *The Infants and their Pet Ambitions*. Some of their ambitions were "to be a jazz baby"; "to walk Ghost Hollow trestle at midnight"; "to love, honor and obey"; "to see that specials are allowed to 'Biz' "; "to be the Bethany Bell"; "to be quite modest and unassuming"; and "to be a vamp and to express her opinion forcibly."

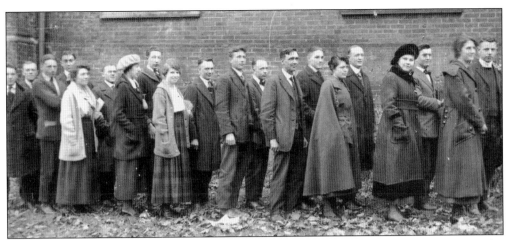

MINISTERIAL & MISSIONARY STUDENTS, 1921. These students were educating themselves for service in the Christian ministry. In 1921, there were approximately 50 ministerial students. Graduates would travel to the far reaches of the planet to spread Alexander Campbell's version of the Scriptures through the United Christian Missionary Society. Bethany College has produced numerous influential missionaries, including Archibald McLean (Class of 1874), who became secretary of the Foreign Christian Missionary Society in 1882 and was elected president in 1900. This was the forerunner of the present United Christian Missionary Society, the world missions arm of the Christian Church. McLean was the editor of the *Missionary Intelligencer*, wrote several books on Christianity, and greatly influenced the Christian Church (Disciples of Christ).

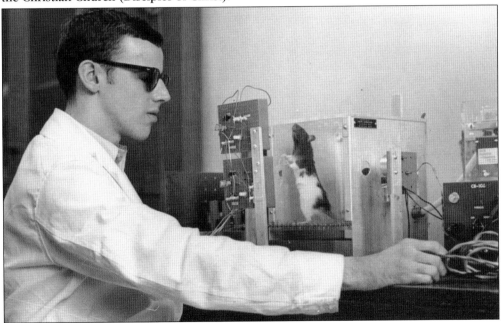

SKINNER BOX, 1967. Charles Edgar McDonald, a blind student and graduate of the West Virginia School for the Blind, found friendship and respect at Bethany College. He is experimenting here with a modified "Skinner Box." Charles was under the direction of Dr. Wilbert Ray, a professor of psychology, who believed that the Skinner Box could be helpful in educating students with special needs such as those McDonald had.

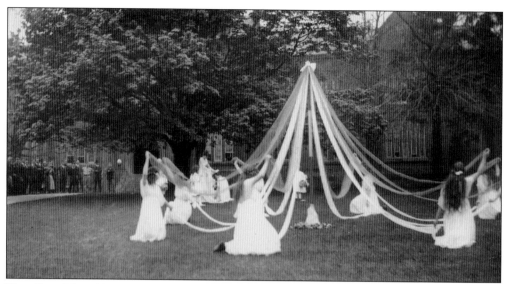

MAY DAY, MAY 13, 1920. The yearbook stated, "the greatest spring event, aside from Commencement, is the May Day Festivity. By the action of the Student Council, the second Thursday of May has been made a college holiday. . . . The Campus had donned its spring garb in honor of the Queen of May. Little flower girls tripped across the grass leading Queen Sue and her attendant. At the throne the Queen was crowned by the Maid of Honor, Princess Sallie. Girls in white with garlands about their heads, danced the May-Pole dance, thus closing the coronation ceremony."

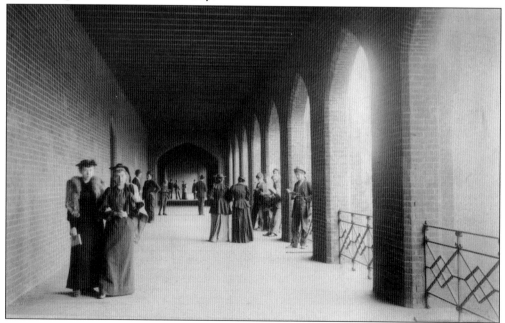

THE CORRIDOR, 1880s. This corridor is the principle causeway in Old Main and one of the most popular places for Bethany students to chat in between classes—notice that every person in the photo is wearing a hat, an uncommon style today. The corridor is 14 feet wide, extends 308 feet from the chapel to the right wing, and is 14 feet high. It was once called the "Arcade for promenading and singing" and was re-floored in 1937.

84

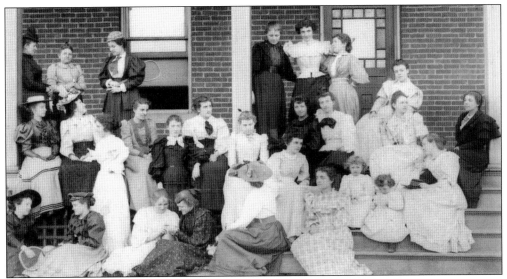

"Call Girls," June 1894. These girls are on the porch of Phillips Hall and referred to themselves on the photo as "Call Girls," probably because the men had to call or announce that they were coming over. The names on the back include Mrs. Appleton, Mrs. G.T. Hawkins, Grace McGrew, Ada J. Morris, Margaret Jobes, Bertha V. Mast, Ms. Ferrall, Grace Fortier, Louise F. Meyer, Minnie Miller, Daisy M. Vogel, Mae Porter, Etta Bryce, Anna Ward, Ethel E. Strickley, Mame Hasseltus, Goldie Berger, Emma E. Banting, Gertrude Frew, Bessie Farras, Sue W. Wright, Fan Brashear, Margaret Appleton, Catharine Ralston, Gertrude Auxter, Mary Jefferson, Louise Jefferson, and Pearl A. Groves.

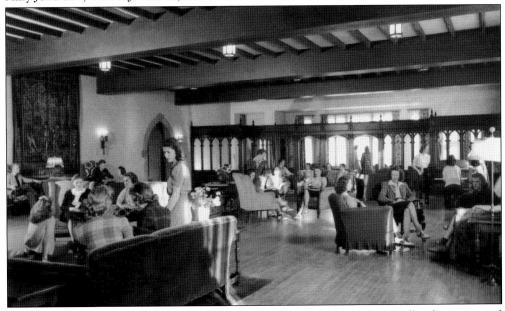

Phillips Hall Lounge, 1940s. B.D. Phillips provided funding for Phillips Hall to be renovated in 1929–1930. This beautiful lounge was where students used to congregate. On the main floor of the new addition were a drawing room and guest rooms. The building also had an infirmary. The lounge was the site of the freshman "Sod Buster's Dance," where the nervous newcomers could get to know other students.

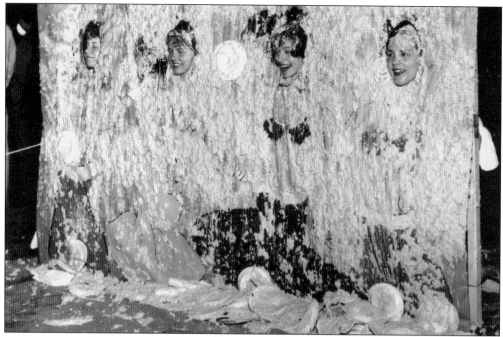

PIE IN THE FACE, 1958. Spring Carnival activities in the 1950s and 1960s included a caravan with king and queen candidates, a cookout, booths with games and $1 kisses, piano smashing, and oatmeal throwing.

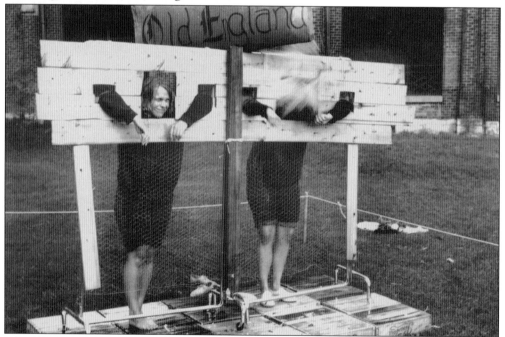

STUDENTS IN STOCKADE, 1964–1965. These students are participating in one of the many unusual activities associated with Spring Carnival. The snapshot was taken at the exact moment that the girl on the left was being hit in the face with a water balloon. Other Spring Carnival antics included dart throwing, "over and under," egg tossing, and a greased pig chase.

86

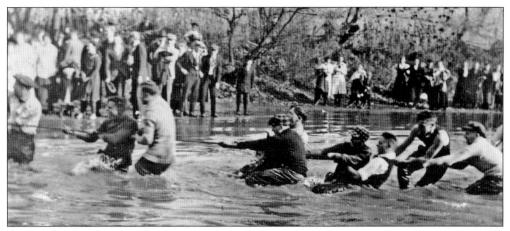

TUG-OF-WAR, 1920. Buffalo Creek has been the site of many bouts of tug-of-war throughout the years. It has been performed during Winter Carnivals, Greek Week, Spring Weekends, and especially after Homecoming. Following a football game, the students held evening programs in the library and during the day had "lavish parades" with floats. Seniors were dressed in white for the parade, and sophomores and juniors in their colors, while the freshman paraded with their donkey cart. One year a seven-act Vaudeville was held after the game, and after the performance each member of the football team was given a box of candy made by the girls. At the end of the evening the football team was robed and crowned. (Courtesy of the scrapbook of Harry Ernest Martin.)

ARBOR DAY, 1927–1928. The students would plant trees and attend lectures about the Parkinson Woods on Labor Day. Alexander Campbell had a deep love of nature and it weighed heavily in his choice of Bethany for the site of his college. Campbell stated, "In the first place, the location must be entirely rural—in the country, detached from all external society; not convenient to any town or place of rendezvous—in the midst of forest, fields, and gardens—salubrious air, pure water."

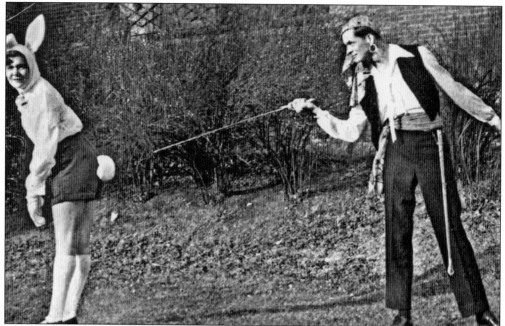

"BIZNESS," 1953. This photograph comes from the collection of Robert Sharpe Jr. (Class of 1953, right), who bears an amazing resemblance to Bob Hope. In the 1927 yearbook there was an entire page devoted to students on "Biz." It featured a Dear Dairy section that stated, "Aunt Pearl held a meeting of the girls to tell them that muddy shoes would be taken as proof that the 'walking rules' were being broken again. Now I'm frightened to death because I always seem to have a 'date' who loves the Beta walk."

EATING IN THE BEE HIVE, 1968. The technical service coordinator at the T.W. Phillips Library, Laura Slacum, identified this photograph from that year's beanie style. The students are eating together in September 1968 in the Bee Hive, where today the Renner Union sits. They are, from left to right, Pat Totty, two unidentified people, Jane Walton, Paul Soly, Cindy Kaufman, Linda Kepner, unidentified, Keith Verbosky, and unidentified.

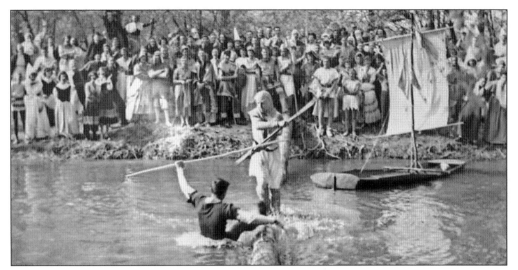

KING ARTHUR'S JOUST, *LIFE* MAGAZINE, MAY 19, 1952. The Spring Carnival at Bethany College was so renowned that it garnered an article in *Life* magazine; King Arthur's Joust was held on May 3, 1952. This exciting day pitted Robin Hood's band of merry men against Arthur's Knights of the Round Table. Among the many activities were a "Little John" stick-fight on a log and jousting on horseback. A local utility company donated two telephone poles for jousting logs. One student was dressed up as the Grim Reaper while others were maidens in distress. Blindfolded students participated in the "Search for the Holy Quail." Arthur's knights staged a grand "Yacht Race" on Buffalo Creek.

ACROBATS PERFORM FOR ROYALTY, MAY 3, 1952. The famous All-American Boys acrobatic team performed during the Arthurian festivities. King Arthur and Guinevere welcomed all visitors to their Appalachian Camelot and hosted an elaborate banquet and dance in the evening. Later on in the night, Merlin appeared and mesmerized the peasantry with a dazzling fireworks display above the tennis courts.

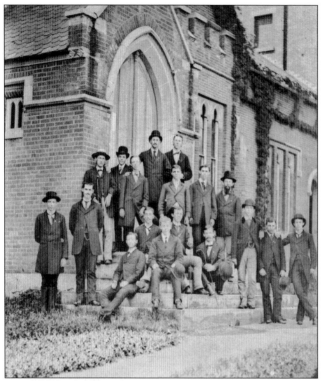

CLASS OF **1880.** Notice that the steps of Commencement Hall have five risers. Also notice the pocket watches with a fob (chain), canes, top hats, and the moss on the walls of Commencement Hall. Unfortunately, nobody is smiling.

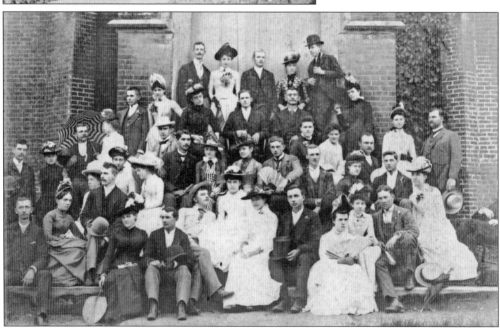

CLASS OF MAY **30, 1892.** The student body is located at the front entrance of Old Main, although 46 students are missing from this photograph. Notice the woman in the front row with the large leaf fan and the man with the huge top hat. A man on the left hand side of the photo is borrowing a woman's parasol for comic effect. A man in the center of the photo is holding a Japanese fan.

PRESIDENT JAMES A. GARFIELD. Before becoming the president of the United States, James A. Garfield was Alexander Campbell's lawyer and friend. He was the only preacher (Disciples of Christ) ever to serve as a U.S. president. He was not ordained, but at the time many preachers were not. At least once he preached on the same platform with founding father Alexander Campbell. He once said, "It was a step down from being an elder in the Disciples of Christ to being president."

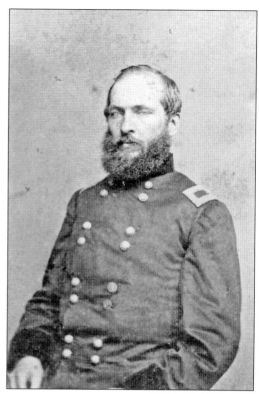

SEN. JOHN F. KENNEDY, 1960. Sen. John F. Kennedy visited during his 1960 presidential campaign. He is pictured with Perry Epler Gresham, president of Bethany College, and Gov. William O'Neill. He spoke at Commencement Hall about his views on Catholicism and whether or not it would work for him or against him during the election.

LYNDON BAINES JOHNSON, CONVOCATION, SPRING 1959. There have been three Christian Church (Disciples of Christ) members to sit in the Oval Office: James A. Garfield, Ronald Reagan, and Lyndon Baines Johnson. Johnson is standing next to Bethany president Perry Epler Gresham.

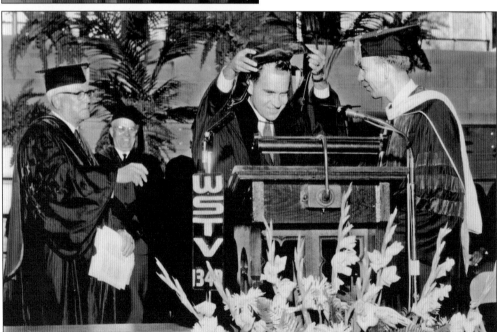

RICHARD MILHAUS NIXON, JUNE 2, 1957. Richard Nixon received an honorary degree from Bethany College as did his future Vice President, Gerald Ford. Nixon is pictured with Bethany president Perry Epler Gresham. Years later, Bethany College would play host to one of President Nixon's strongest critics, John Kerry. Fortunately, they weren't here on the same day.

Nine

NOTABLE BETHANIANS

JOHN MARSHALL, CLASS OF 1902. After graduation, Marshall attended Yale University, earned a Bachelor of Laws degree from West Virginia University, and was a West Virginia delegate three times during the 1920s. Marshall served as assistant attorney general of the United States from 1925 to 1929. He was awarded an honorary Doctor of Laws degree from Bethany College in 1936 and was on the board of trustees from 1924 to 1966. John Marshall was not the first member of his family to hold this position, as his grandfather, Campbell Tarr, served on Bethany College's first board of trustees (1840–1860).

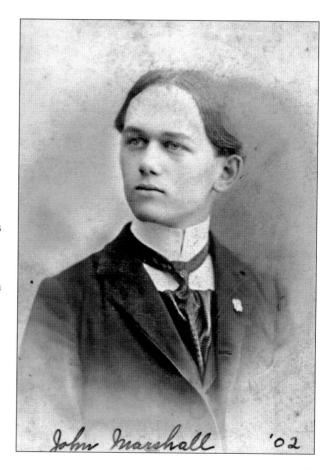

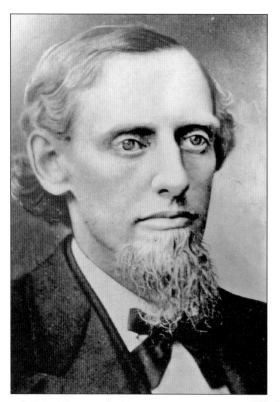

AMOS EMERSON DOLBEAR, FACULTY 1868–1874. Amos Emerson Dolbear (1837–1910) invented the first permanent magnet telephone receiver (1876) and the electric static telephone (1879). His name should be as well known as Alexander Graham Bell, but he failed to patent his invention in time. Alan MacDougall, president of the Tufts Alumni Association said, "We at Tufts feel Dolbear actually came up with the first telephone—he just didn't patent it quick enough." Amos Dolbear was a professor of natural science at Bethany College from 1868 to 1874. The faculty physicist ran the first telephone lines down the corridor of Old Main. He also served as the first mayor of Bethany from 1871 to 1872.

THOMAS BUERGENTHAL, CLASS OF 1957. Judge Thomas Buergenthal was a professor at the George Washington University Law School, dean at American University, Washington College of Law, and president of the Inter-American Court of Human Rights from 1979 to 1991. He was also a member of the United Nations Human Rights Committee from 1995 to 1999. Judge Buergenthal is the U.S. national judge of the International Court of Justice. As a young man, Judge Buergenthal was a survivor of the infamous Nazi concentration camp Auschwitz. Comparing a piece that he did for the *Literary Harbinger* in 1956, "The Death Transport," with a talk that he gave at the U.S. Holocaust Memorial Museum in 1995, he said, "The juxtaposition of the 1956 Bethany piece and the 1995 talk provides some evidence of the healing effect that the passage of time has on the capacity of human beings to cope with terrible memories."

FORREST HUNTER KIRKPATRICK, CLASS OF 1927. The *Bethanian* describes Forrest Kirkpatrick, saying, " 'Kirk' does more than all the faculty and student body put together, and still finds time to make good grades." After graduation, he became a college professor, administrator, and an industrial expert in personnel management. This driven man also found time to establish the Senior Comprehensive Examinations and Gamma Sigma Kappa in the 1930s and found Kalon in 1948. He funded the endowment scholarships designed for the children and grandchildren of Bethany alumni in 1974 and arranged for the remodeling of the Oglebay Hall of Agriculture. The Kirkpatrick Hall of Life Sciences is named in his honor.

WILLIAM H. MACY (ATTENDED 1969–1970). William H. Macy attended Bethany College to study veterinary medicine but soon found that his real passion was for drama. He is seen here in a Bethany production of Samuel Beckett's play *Waiting for Godot*. Macy left Bethany sometime after his first year to study under the playwright David Mamet at Vermont's Goddard College. Later Macy would play Dr. David Morgenstern on the popular television show *ER*. He has appeared in dozens of movies, including *Wag the Dog*, *Sea Biscuit*, *Mr. Holland's Opus*, *Searching for Bobby Fischer*, *Jurassic Park III*, *Boogie Nights*, and *Magnolia*. He won an Oscar nomination for his memorable portrayal of Jerry Lundegaard in *Fargo* (1996). In that movie he played opposite another Bethanian, Frances McDormand.

FRANCES LOUISE McDORMAND, CLASS OF 1979. Frances McDormand probably learned about Bethany College because her father, Vernon, was a minister for the Disciples of Christ. She honed her acting skills at Bethany College by performing in many school productions and received a Bachelor of Arts in theater. Fran has worked on Broadway and was nominated for a Tony for her portrayal of Stella in *A Streetcar Named Desire*. She has played distinctive roles in numerous movies, including *Raising Arizona, Miller's Crossing, Wonder Boys, Blood Simple, Laurel Canyon*, and *City by the Sea*. Frances has been nominated three times for an Oscar including Best Supporting Actress nominations for *Mississippi Burning* (1988) and *Almost Famous* (2000). Frances won an Oscar for playing Marge Gunderson in *Fargo* (1996).

FAITH (SKOWRONSKI) DANIELS, CLASS OF 1979. While at Bethany College, Faith (far right) won several writing awards, such as the Golden Quill Award, the Ed King Memorial Award, and the Matrix Award. During the 1975–1976 school year, a razor blade found its way into Faith's jewelry box, and the girls from Phillips Hall believed it was a ghost whom they named Horace. In 1986, Faith received the honorary degree Doctor of Communications from Bethany College. She went on to fame as a co-anchor of the *CBS Morning Show* and an interview show called *A Closer Look with Faith Daniels*. She was also an anchor for the *NBC Morning News at Sunrise* and often did the news on the *Today Show*. The April 1991 edition of *McCall's* Magazine cover asked the question, "NBC's New Jane Pauley?"

Tom Gordon Poston, Attended 1939–1941. This Emmy-winning actor flew planes for the Air Corps on D-Day when he dropped paratroopers behind enemy lines. He won medals for valor for his heroism on that pivotal day in World War II. Most people know Tom Poston from his numerous television appearances, including *The Love Boat*, *Get Smart*, *ER*, *The Phil Silver's Show*, *What's My Line?*, *Murphy Brown*, and especially *Newhart*, where he played George Utley. He married Suzanne Pleshette from *The Bob Newhart Show*.

Earl Williams Oglebay, Attended 1867–1869. Earl Williams Oglebay was in the Neotrophian Literary Society while at Bethany College. Colonel Oglebay later became an influential industrialist and philanthropist, and his gracious gifts still adorn the campus. Colonel Oglebay made millions in the iron-ore industry and built the beautiful Waddington Farm that has since become Oglebay Park. His donations to Bethany College include the clock in the tower in 1904, the Oglebay Gates in 1910, and the Bethany College Farm in 1912. He is a member of the Wheeling Hall of Fame and his summer home, Oglebay Mansion, is on the National Register of Historic Places. After Society Hall burned down, Oglebay contributed money for its reconstruction; it was named Oglebay Hall of Science and Agriculture.

JAMES BEAUCHAMP CLARK, CLASS OF 1873.
James "Champ" Clark was elected to the United States Congress from 1893 to 1895 and again from 1897 to 1921. In 1910 he waged a campaign to strip the speaker of the house of many of his more "dictatorial powers." Ironically, he became speaker of the house of representatives one year later (1911–1919). This powerful Democratic leader campaigned for the Democratic nomination for President in 1912, but a two-thirds majority was needed to win the nomination. Clark led on 30 ballots, but Nebraska's delegate, William Jennings Bryan, helped swing the nomination to Woodrow Wilson.

MARC MORDECAI COCHRAN, CLASS OF 1875.
This industrious young man made money by taking supplies down the Ohio River on boats to Cincinnati. After leaving Bethany, M.M. Cochran attended Yale Law School and graduated with honors. He accepted the Democratic nomination for district attorney in his county in 1883 and helped establish the Coke Region Mission Work for Christian Churches. This group built churches in New Salem, Republic, Brownsville, and Mather. In 1881 he was elected to the Bethany College Board of Trustees and spent the rest of his life promoting the welfare of Bethany College. Cochran Hall is named in honor of his son Percy.

ALAN DALE FIERS, CLASS OF 1929. After graduating from Bethany College, Dale Fiers earned a degree from Yale Divinity School and continued his studies at the Union Theological Seminary. He was awarded an honorary Doctor of Divinity from Bethany College and served as a member of the board of trustees for 30 years. Dale Fiers was the first general minister and president of the Disciples of Christ from 1968 to 1973, president of the United Christian Missionary Society, and executive secretary of the International Convention of the Christian Church (Disciples of Christ). Dale Fiers helped to restructure the missionary arm of the Christian Church to make it more egalitarian. He was the subject of a biography entitled *Dale Fiers: Twentieth Century Disciple*, by D. Duane Cummins.

EDGAR ODELL LOVETT, CLASS OF 1890. Edgar Lovett played baseball while at Bethany College and was a member of Beta Theta Pi and the Neotrophian Literary Society. This famous missionary disciple was the editor of the *World Call* magazine. Lovett received a Master of Arts in 1894, a Ph.D. from Leipzig in 1896, and an honorary L.L.d. degree from Bethany College in 1934. He was a professor of astronomy at Princeton University. He became the founding president of Rice Institute (1908–1946), which later became Rice University. Lovett received the French decoration of Officer Legion d'Honneur in 1938.

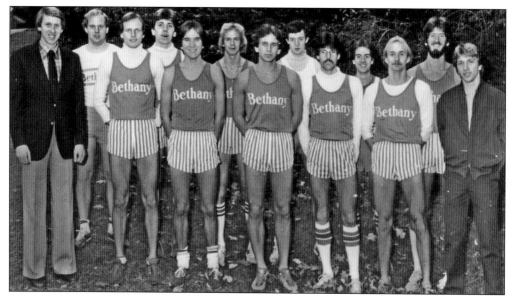

DAVID WOTTLE, CROSS COUNTRY COACH, FACULTY 1979–1982. David Wottle, far left, was the 1972 NCAA champion in the 880-meter race and the NCAA champion in the mile relay. He won a place on the 1972 United States Olympic Track Team but was injured between the trials and the games. Many people thought that he couldn't overcome the injury. In the 1972 Munich Olympic Games, David prevailed over the skepticism and won the 800-meter race in the last few steps with a time of 1:45.9. He is also remembered for forgetting to take off his white cap during the victory ceremony. This was not a protest but rather a moment of forgetfulness.

WILLIAM MARC HARSHMAN, CLASS OF 1973. William Marc Harshman began his career writing for the *Harbinger* at Bethany College. He has published numerous children's books, including *All the Way to Morning* and *Red are the Apples*, as well as two volumes of poetry. In 1993 Harshman received the Literary Merit Award from the West Virginia Library Association. He was also an elementary school teacher in Marshall County.

GEORGE MIKSCH SUTTON, CLASS OF 1919. George Sutton was one of the world's foremost ornithologists and bird artists. He received a doctorate from Cornell University in 1932 and an honorary Doctorate of Science from Bethany College in 1952. The adventurous Sutton studied birds in the Arctic and the Mexican jungles, authored 11 books, and illustrated 15 publications. One of his most popular was *Iceland Summer: Adventures of a Bird Painter*. The University of Oklahoma built Sutton Hall in honor of Sutton, one of its best-loved faculty. This building houses part of the zoology department. The Bethany Chapter of the National Audubon Society was named the George M. Sutton Audubon Society in 1969. Many of his prints are kept in the art collection in the archives and special collections.

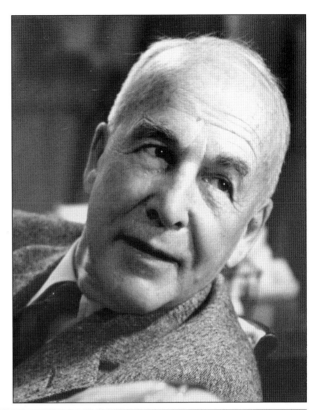

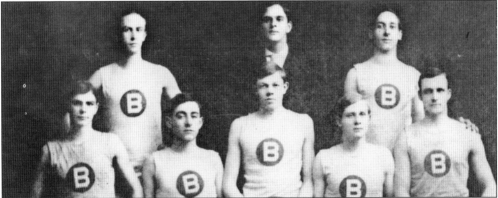

JOHN TATE RIDDELL, CLASS OF 1909. John Riddell (back row, left) came to Bethany as a sophomore and played basketball, baseball, and football but had to sit on the sidelines after a serious injury in the fall of 1907. He was in the Neotrophian Society and Sigma Nu and graduated with a Bachelor of Arts in the classics course. After graduation, Riddell began experimenting with athletic equipment. At the time, football cleats, made of leather and nailed to the soles of the shoes, were cumbersome to replace or repair. Riddell patented the first removable cleats. He started John T. Riddell, Inc. in 1929, and it created the first molded, seamless basketball. However, during World War II, pure latex became unavailable. Next, Riddell worked out a way to replace the soft leather helmets with a hard plastic shell. Once again, World War II made plastic unavailable, but this time the federal government asked Riddell to grant them a license for his inner webbing and suspension design for his helmets. Riddell agreed and probably saved many lives during the war.

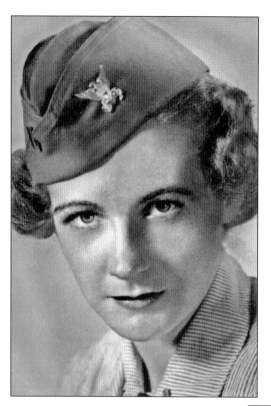

HELEN LOUISE McGUFFIE, CLASS OF 1936. Helen Louise McGuffie was on the faculty as a professor of English from 1947 to 1983. In 1954, she was named head of the English department and served 23 years in that capacity. The McGuffie Fund was established in her honor and provided funds for campus visits by guest lecturers and poets. She was associated with Bethany College for over 50 years. She was also an ensign in the U.S. Coast Guard during World War II and a Samuel Johnson scholar.

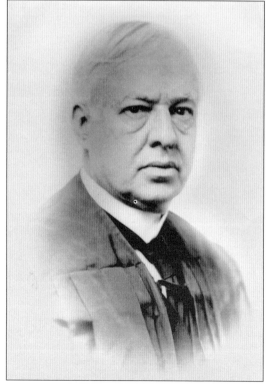

JOSEPH RUCKER LAMAR, CLASS OF 1877. Joseph Rucker Lamar was a member of Beta Theta Pi and a pitcher for the Bethany team. After graduating in the classics course, he won a seat in the Georgia state legislature in 1886. He went on to win a spot on the Georgia Supreme Bench in 1903 and was appointed to the Supreme Court of the United States in January 1911. While in Washington, D.C., he renewed his boyhood friendship with President Woodrow Wilson.

JAMES MARCUS RIDENOUR SCHUYLER, ATTENDED **1941–1942**. James was on the editorial staff of the school newspaper but was put on probation in 1942. He withdrew on January 28, 1943, and was later denied readmission. James stated that his poor grades were due to excessive bridge playing. After leaving Bethany, he joined the navy and was later associated with the New York School of Poets. James won the Pulitzer Prize for poetry on April 13, 1981, for the poem "The Morning of the Poem." He was also a novelist, playwright, and art critic. His poem "Pastime" follows:

> I'm shaky. A shave, a bath.
> Chat. The morning paper.
> Sitting. Staring. Thinking blankly.
> TV. A desert kind of life.

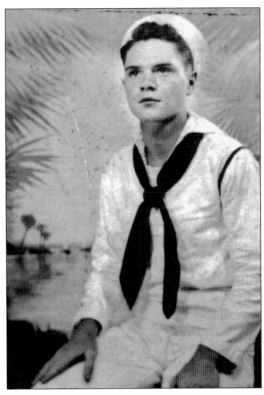

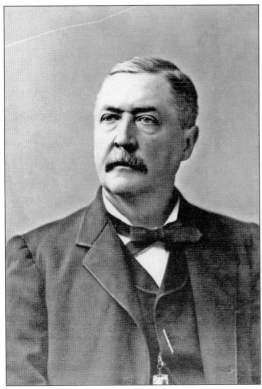

ARCHIBALD W. CAMPBELL, CLASS OF **1852**. At the age of 19, Archibald Campbell graduated from the college that his uncle Alexander had founded. He bought the *Wheeling Intelligencer* in 1856 and soon became its editor. He used his position to petition his good friend Abraham Lincoln on behalf of West Virginia statehood. He wrote, "I am in great hopes that you will sign the bill to make West Virginia a state. The loyal people have their hearts set upon it." President Lincoln signed West Virginia into statehood ten days later. Many citizens believed that Campbell's letter was an important factor. He is a member of the Wheeling Hall of Fame.

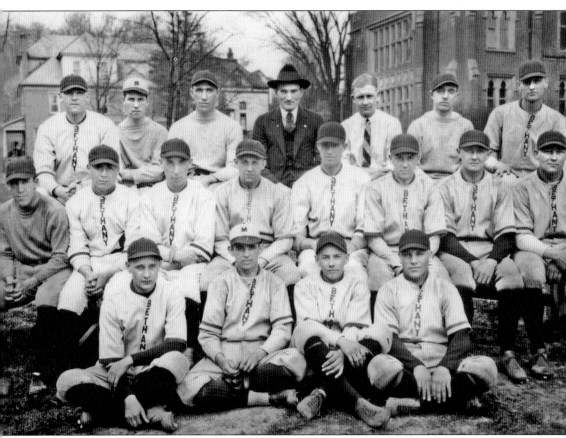

WILLIAM EDWIN WELLS, CLASS OF 1924. Wells (back row, left) and his fellow classmates Paul Pritchard and Harry Fitz Randolph were dubbed "The All American Pitching Staff" by the press. Wells's buddy Harry was named the "Bethany Babe Ruth" in his senior yearbook. Ironically, Wells was one of the only professional pitchers that the real Babe Ruth had trouble hitting. Legend has it that Wells was so successful during his time with the Tigers that the Yankees traded for him so that the "Bambino" would never have to face him.

Ten

THEN AND NOW

RACCOON COAT CHEERLEADER, 1940s. This exuberant student is cheering a Bethany sports team to victory. He is wearing a boating hat and fur coat and chewing on a corncob pipe. Bethany College has had a long tradition of pep clubs, starting with Moo Moo Moo (1923). The relative seclusion of the college and its strong traditions have produced a unique esprit de corps. In October 1969, faculty members gave Pearl Mahaffey a gift in the form of a willow oak tree that was planted between Old Main and Steinman Hall. The gift was part of a birthday party that was organized by John Taylor. The inscription on a stone marker reads "Pearl Mahaffey dares you to love this place as she does." The guy in the raccoon coat obviously took the dare.

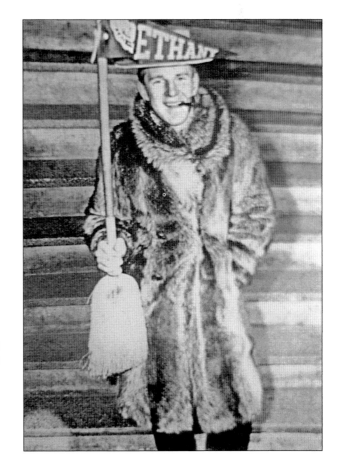

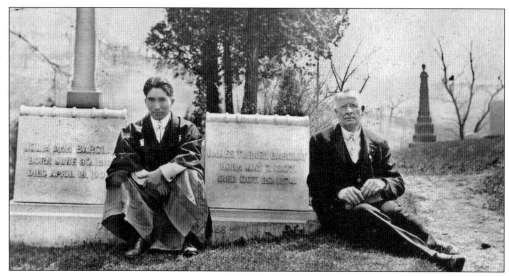

INTERNATIONAL EXCHANGE, 1916. Bethany College was light years ahead of other local colleges with exchange programs, extending back to the 19th century. U.G. Houston, right, was the oldest student on campus. Rinzo N. Suzuki was an exchange student from Japan. The college's commitment to multiculturalism has not faded as Bethany College has held an annual Japan Week for many years. During this celebration, students and scholars come from far and wide to witness demonstrations on different aspects of Japanese culture and discuss the similarities between the two countries.

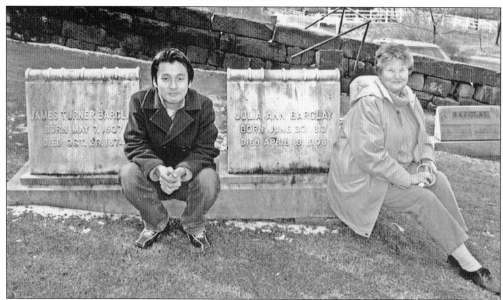

INTERNATIONAL EXCHANGE, 2004. On the left is Yosuke Yamada, a Bethany student from Tokyo, Japan. He is a junior and is president of both the Japan Club and the Photo Club. R. Jeanne Cobb, archivist and coordinator of special collections at the T. W. Phillips Memorial Library is on the right. She has worked for Bethany College since 1988 and her husband, William Daniel Cobb III, was the vice president and dean of faculty at Bethany College (1977–1986). He is buried in Campbell Cemetery along with other long-term faculty and administrators of the college and their families.

TURN STILE, JUNE 9, 1895. The stile was placed here to prevent livestock from entering the college grounds. The photographer was looking down College Street at Cowan's Livery Stable on the southeast corner of the intersection at College and Main Street. Visible on the right is part of Isaac and Sophie Stewart's Ranche (site of the present Cochran Hall). The old Bethany House is hidden behind the trees on the left at Sharp Corner (present site of the new Bethany House).

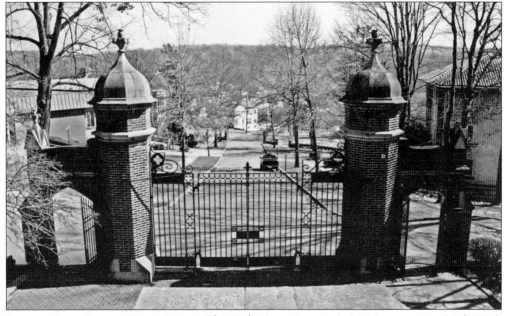

LOOKING DOWN COLLEGE STREET, MARCH 14, 2004. The author took this photo on March 14, 2004, from the north side of Oglebay Gates. Cochran Hall is on the right, and straight ahead, where the livery stable used to stand, is a vacant lot.

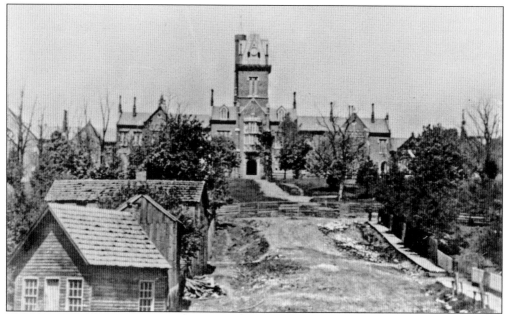

LOOKING UP COLLEGE STREET, 1891. The Bethany House is on the right, and on the left is Isaac and Sophie Stewart's Ranche. The building in the left front of the photograph was a shoe repair shop. On July 7, 1891, Bethany passed an ordinance that a sidewalk be laid. Notice the rugged dirt streets.

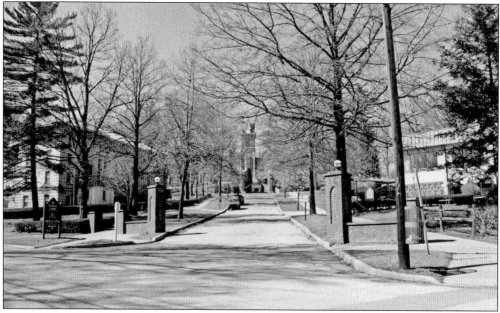

LOOKING UP COLLEGE STREET, MARCH 14, 2004. This is the intersection of College and Main Streets. On the left is Cochran Hall and on the right is Benedum Commons and Bethany House. The stone pillars, dedicated on June 5, 1933, by the Class of 1933, were from the Old Bethany House that was burned down by a confessed student arsonist on November 21, 1932. Immediately after the fire, students arrived at the scene and began to sing "It is a Hot Time in the Old Town Tonight" and "Keep the Home Fires Burning."

COLLEGE PROPER AND STEWARD'S INN, 1842. These were the original college structures of Bethany College. Steward's Inn, on the left, was completed in the fall of 1841 and served as the student dorm and dining facility. College Proper, on the right, was completed in the spring of 1842 and was the main academic building. Currently, the concrete walkway between Cramblet Hall and Phillips Hall is the approximate location of Steward's Inn. The northern portion of Gresham Gardens marks the site of the original college building. College Proper was built in the Federal style.

COLLEGE RUINS, SPRING 1858. This photograph was taken after a fire consumed College Proper, which burned on December 11, 1857. The cornerstone of the new college building, (Old Main) was laid on May 31, 1858. Pendleton Heights can barely be seen in the background as can the ruined brick foundation of College Proper. One can also see forked support poles, wood planks, and a lean-to for building materials. The burned bricks were salvaged and used for the new college edifice—notice the fence that separated Pendleton Heights from the campus. If a photographer was to stand on the same spot, this would be on the south side of Alumni Walk between College Drive and Gresham Gardens.

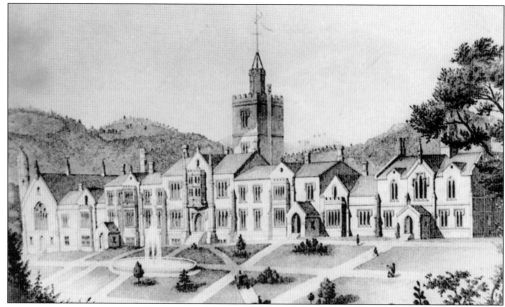

APPEAL TO THE ALUMNI, NOVEMBER 20, 1860. Pres. Alexander Campbell and Treas. William Kimbrough Pendleton made a decision on December 14, 1857, to develop a new building. This letter of appeal to the alumni was a plea for funding for the new college buildings. This particular letter was sent to Bethany alumnus Thomas Humphrey Wynne's father, F.H. Wynne, in Yorktown, Virginia. The first proposal had a fountain and a clockless tower. In 1998, a water fountain (ie. Gresham Gardens) was placed in front of Old Main.

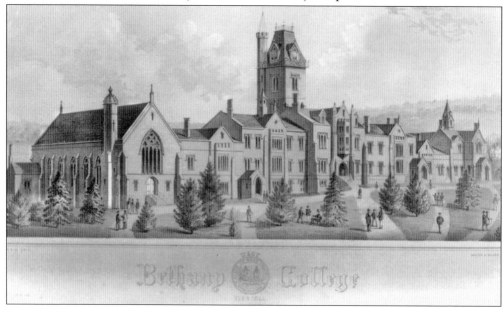

APPROVED DESIGN. This tinted-color lithograph, drawn by Middleton and Strobridge of Cincinnati in 1858, shows the revised plan that was taken before the board of trustees. This proposal with its Gothic Revival design was approved by the board. It features a clock tower and no fountain. The building was designed by James Key Wilson of the firm Walter and Wilson of Cincinnati.

110

VIEW FROM THE TOWER, SUMMER 1909–1910. This photo was taken from the tower in the same year that Bethany experienced a terrifying typhoid epidemic. In the winter of 1910, 18 Bethany College students became ill but none died. After the Stewart Ranche was torn down, the materials were thrown into the spring on the property, which contaminated the water and reportedly caused the epidemic. The view is from the tower towards the southeast at the intersection of Main Street and College Street. Visible are the livery stable in the center of the photo and the bare spot where the Stewart Ranche was razed to make room for Cochran Hall.

VIEW FROM THE CAMPBELL TOWER, MARCH 19, 2004. A maintenance man, Hank Cook, led the author up the 160 wooden steps to the top parapet surrounding the clock on the tower. Two-thirds of the way up, a storage room displays graffiti from as early as 1890. Rumor has it that the author's signature and one of a Bethany College archivist can now be seen in the same room. The clappers that should be inside the bell are presently being used as andirons in Phillips Hall. They had been stolen so many times that the administration decided to remove the temptation. In 1902, Frank J. Kent wrote "The Bell Song." The chorus begins, "The bell in the tower is ringing, ringing, And Bethany's children respond to her call; They march on the corridor singing, singing 'Old Bethany we love thee, thou fairest of all.' "

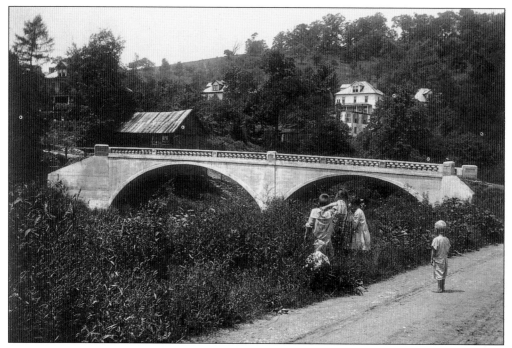

KD Bridge, 1919. The little boy standing on the road is Joe Funk. The girl in plaid is believed to be Claire or Lennie Schley. The others are unidentified.

KD Bridge, March 26, 2004. Laura Slacum ("Wib" Cramblet's daughter) wears the Bison mascot suit on the KD Bridge. The sign on the bridge says "S–305–62–704, Bridge No. 3509, Built 1988." Standing with Laura are senior Shannon Boyle (right) and Amy Stoner (left). Shannon is on the basketball team and Amy is on the softball team. The Bison Crossing signs were created by Suzi Cummins and first used for an Alumni Weekend, but by Sunday night almost all of the signs had been taken by nostalgic guests or students who wanted souvenirs. This one is under lock and key in the archives of T.W. Phillips Library.

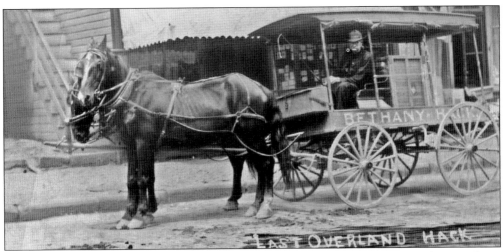

BETHANY HACK, 1916. The Bethany Hack took students the bumpy seven miles from Bethany to Wellsburg at least as early as the 1850s. The hack left Bethany at 8:00 a.m. and arrived in Wellsburg at 9:30 a.m. The hack ceased operation in 1916 when it was replaced by the trolley. This snapshot was taken somewhere on Main Street. A student from the 1890s stated that William Pendleton Cowan drove the hack before the 1880s. Students protested when it ceased, saying, "No one can appreciate the social advantages of the Bethany Hack who has not ridden in one. A hack is filled with students, they are discussing questions of momentous importance to the state, the nation, and the world." Another student said, "If Shakespeare was here, he would be opposed to this trolley line, and strongly in favor of reviving the Bethany hack." Notice how skinny the horse looks.

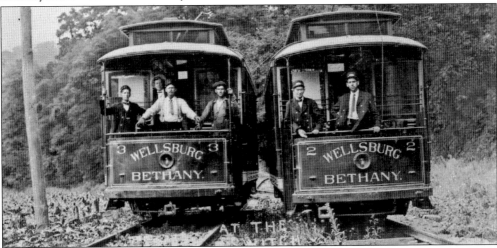

"TOONERVILLE TROLLEY," 1920. These two trolleys are close to the halfway point between Bethany and Wellsburg. Popularly known as the "Toonerville Trolley," the Wellsburg, Bethany, and Washington Railroad Company was granted the right of way "through the pasture field of the college south of the college campus" on October 29, 1906. It commenced operations by June 9, 1908, and continued until 1925, at which time the bus replaced it. The tracks were removed by the winter of 1929. Tradition has it that Fontaine Fox originally got his idea for the comic strip *The Toonerville Trolley* from this line. The car barn was located below Phillips Hall. A trip from Wellsburg to Bethany took 45 minutes. The charge for cattle was $2 a head and 25¢ one way for passengers.

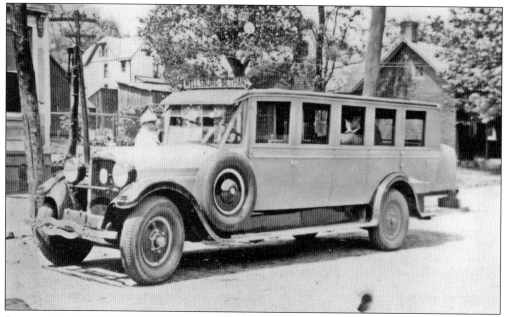

BETHANY BUS, 1935. This old bus was one of the Bethany buses used to transport students the 20 minutes to and from Wellsburg. This photograph was taken in front of a sign advertising Scotts Ice Cream. Students cherished their time on the Bethany bus so fondly that pictures of it were sent to GIs during World War II to give them a feeling of home.

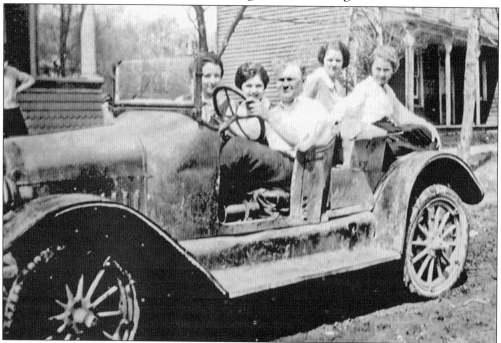

CAR ON MAIN STREET, 1920–1924, These girls are probably from the Alpha Xi Delta sorority, as the photograph came from the scrapbook of AXD member Rosemary Gillette. In 1904 the first auto arrived in Bethany. It was abandoned at Point Breeze and carried by four men to the corridor of Old Main. It was repaired and driven noisily up and down the corridor.

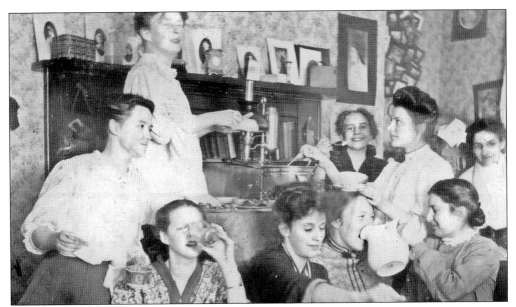

REFRESHMENTS, JANUARY 3, 1900. These girls from Phillips Hall are enjoying some homemade refreshments. The only name on the photograph is Eunice Orrison. Perhaps the others were too "happy" from their refreshments to write their names down. Notice that one girl is drinking out of a pitcher and has a cup on her head. They are also brewing some concoction in a punch bowl.

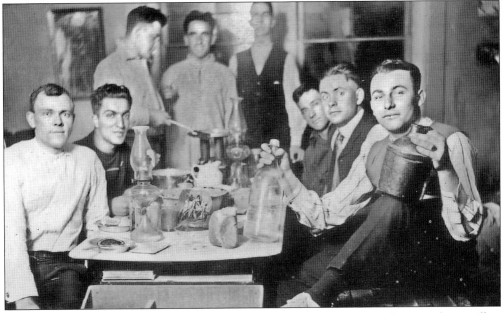

RENNER AND FRIENDS, 1921. The men drinking are identified on the photograph as Miller, Renner, Danks, Dairian, Myers, Miller and Burghart. The photo leads one to speculate whether they might be drinking moonshine, as there were many stills around this area. Notice the bread, hand-rolled cigarettes, and the name Renner. Think of this photo the next time that you are in the Renner Visitor Center on the second floor of Bethany House. (Courtesy of the scrapbook of Harry Ernest Martin.)

TOGA AND DRINKING, 1993–1994.
The boys of Alpha Sigma Phi are
giving their impersonation of Otter
and Bluto from *Animal House*.

THE SATURDAY NIGHT CREW AT BUBBA'S, MARCH 2004. From left to right are Todd "Flood" Jones (Class of 1985); Carl "Weasel" Kaylor (Class of 1990); Dave Douglass (Class of 1989); Kim Allison, lifelong Bethanian (her father was math professor Jim Allison); and Chuck Kern (Class of 1980). At the time of this photograph Kim and Dave were engaged.

UNDER THE MISTLETOE, DECEMBER 1955. The students are identified on the snapshot, from left to right, as Glen Helme, Stephanie Jones, Joni Bange, and Bill Thompson. The front of Old Main was the setting for the fake mistletoe.

NOSE TO NOSE, MARCH 23, 2004. Sophomores Matt Porter and Dana Culbert met four months ago on the Bethany campus and fell in love. They are nose to nose in the John J. Knight Natatorium of the Thomas Phillips Johnson Health and Recreation Center. In 1930, John J. Knight became the director of athletics and was the head baseball, track, and football coach. In 1959, John J. Knight was elected president of the National Association of Intercollegiate Athletics (NAIA) and was inducted into the NAIA Hall of Fame in 1963. Knight retired in 1970 and was granted emeritus status.

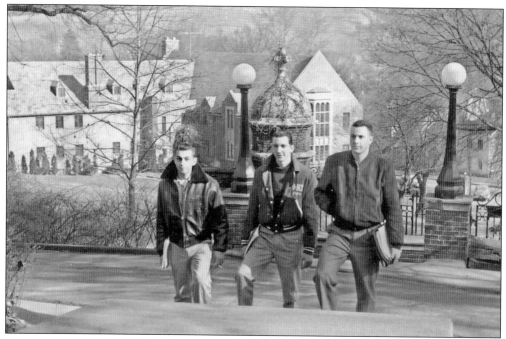

BIG MEN ON CAMPUS, 1957–1958. Juniors Mike Herwitt, Dick Schillinger, and Dave Greenberg are walking tall behind Oglebay Gates. Notice the conservative hair styles, fraternity jacket, leather jacket, and khaki pants.

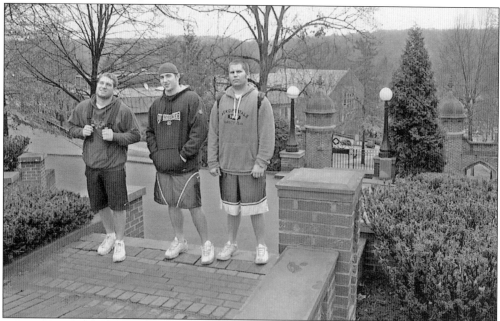

BIG MEN ON CAMPUS, MARCH 2004. Eric Givens, Michael Elias, and Paul Duffy are posing in the same spot where their 1950s counterparts were standing. Notice the green roof of Benedum Commons, which was not present in the 1958 photograph. The brick pillars along Alumni Walk are also different. The guys have a more casual approach towards their classroom apparel.

"WASHBOARD FALLS," 1992–1993. This photograph was taken by Prof. William R. Warren, who taught ancient languages at Bethany College. There are numerous falls around Bethany and even more local nicknames for them, including Three Falls, Hibeman Cave, Cascade Falls, Fire Clay Falls, Mingo Ravine Falls, and Washboard Falls to name just a few.

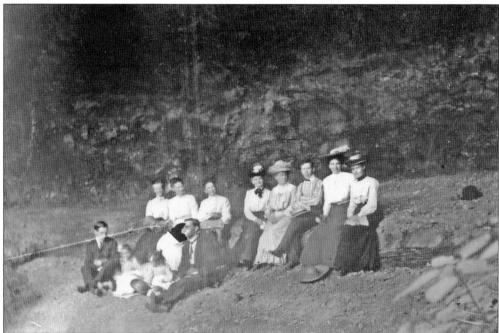

CAVE PICNIC, 1903. This photo is probably at Hibeman Cave, but there are many falls and caves around Bethany, and the names are constantly changing. Students used these caves for "Biz" because they were difficult to get to and thus made them a relatively safe haven from the faculty. However, these women made it there in shirt waists (blouses) and skirts.

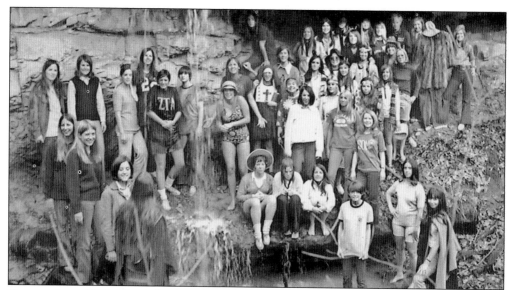

ZETAS AT CAVE, 1970. The girls of Zeta Tau Alpha are identified as Dale Morris, Joanne Putnam, Luba Routsong, Jory Smith, Carol Gustafson, Sherry Cox, Kathy Woodward, Barb May, Wendy Polite, Carol Schoff, Kathy McNeil, Nancy Strukle, Sidney Drewry, Dianne Keiser, Nancy Crimmins, Peggy Housman, Sandy Llewellen, Betsy Allen, Lisa MacFarline, Julie Bartlett, Ceil Merrit, Kris Waite, Linda Armington, Patsy Lee, Karen Butler, Eileen Hill, Nancy Sweer, Gay Feche, Terry Baile, Jeanie Davis, Cindy Groomes, Kathy Dunobaugh, Betsy Proctor, Carolyn Putnam, Bitsy Merrill, Carolyn Miller, Patty Pasalo, Joey Rackly, Robin Brown, Laura Goldsmith, Kathy Conklin, Sue Smyth, and Cindy Cippoletti. Notice the nun's outfit, the fur coat, and the flower power girl.

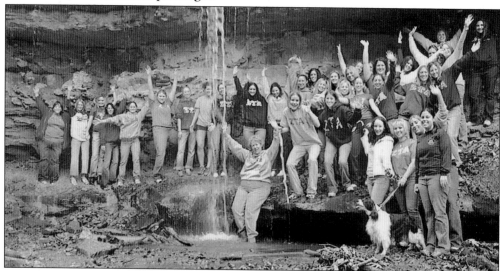

WEIMER TRAIL FALLS, MARCH 25, 2004. The Zetas returned to a Bethany waterfall on Weimer Trail on March 25, 2004. The girls identified themselves as Lisa, Ashley K., Meredith, Alyssa, Pam, Lindsay, Jess, Jaclyn, Bianca, Dana, Danks, Nataleigh, Ashley D., Britt, M. J., Heidi, Jaime, Kate, Alexis, Megan, Jackie, Katie E., Jenny B., Jersey, Megan P., Jennie, Sara, Angeline, Gina, Tiff, Megan, Laura, Melissa, Meghan, Jenn, Foose, Jamie Hill, Laura, Stefanie, Judge Joyce Chernenko, and "Marshal" the dog.

WORLD WAR I. Bethanians have rendered service to their country in every war since the Civil War. The Bethanian in the photo is Paul E. Reeves (Class of 1918). The 1919 issue of the *Bethanian* listed 155 men currently in the "Honor Roll of Men In the Service." It said, "In Memoriam: To you, noble sons of Bethany who have fallen in the cause of the World's democracy, we dedicate this page. It is with sorrow that we are not to see you more, or feel the touch of your lives molded by the influence of your ennobling sacrifice; but it is with joy that we remember you as among Bethany's truly great men." (Courtesy of the scrapbook of Harry Ernest Martin.)

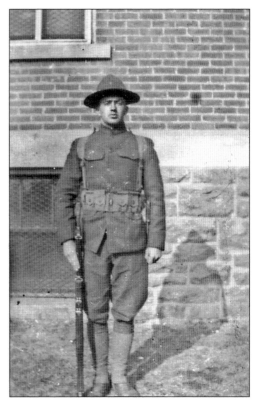

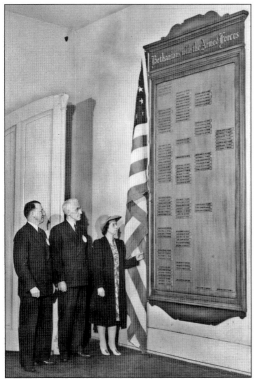

CONCERNED PARENTS, SPRING 1943. During World War II there was a plaque to the corridor of Old Main dedicated to the student soldiers that were fighting on foreign shores. This photograph and many others were mailed to the servicemen to let them know that their family, friends, and alma mater had not forgotten them. There is still a plaque in front of the president's office honoring Bethanians who lost their lives in World War II.

121

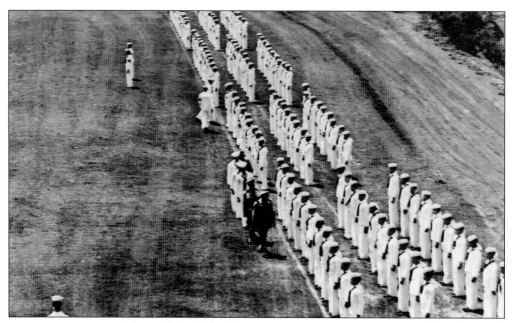

NAVY V-12 PROGRAM, 1942–1943. Forty-two air cadets came to Bethany campus in the summer of 1942 with the hopes of producing college-trained officers for the navy. By May of 1943, 87 cadets had finished the rigorous training. Bethany College was one of 131 campuses selected for this program. The goal was "to ensure a constant stream of intelligent college-trained officers to man the navy's ships." By April 19, 1945, the program was nearing its end. In all, the navy V-12 program brought 836 sailors to the Bethany campus between 1942 and 1945.

LT. COL. GARY A. WINTERSTEIN, CLASS OF 1985. Lt. Col. Gary A. Winterstein has served his country with distinction in the U.S. Marine Corps since 1982. He graduated from Bethany College with a Bachelor of Arts in communications, and his senior project while at Bethany was fittingly titled "Sanity and Survival: Yours, Mine and Ours." His assignments have included the Pentagon and the National Security Agency, as well as service in Europe, Asia, Africa, Australia, and the Americas. His personal decorations include the Navy and Marine Corps medal, Meritorious Service medal, the Joint Service Commendation and Achievement medals, and Navy Commendation and Achievement medals.

**"Our Democracy is a Farce,"
November 2, 1971.** John Forbes Kerry, 27, spoke at the Weimer Lecture Hall as the leader of the Vietnam Veterans against the War. He chastised the Nixon administration, saying, "The government can kick people around." He opined that "our democracy is a farce; it is not the best in the world."

Peace, Love, Flowers, and Protest, 1970. The 1970 yearbook described the peace rallies and flower children on campus by saying, "The motive was the same: a desire for freedom of expression. This freedom was virtually uninhibited by Bethany College administration and resulted in the eventual liberalization of College policies while maintaining College ideals and principles." The largest rally occurred after the shootings at Kent State.

123

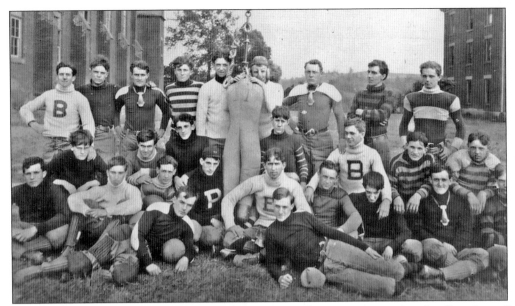

FOOTBALL TEAM ON QUAD WITH DUMMY, 1904. The 1904 season was under the direction of Coach C.S. Wells and ended with three wins, four losses, and two ties. Phillips Hall is on the right and Commencement Hall (Norman A. Phillips Dormitory for Men) is on the left. Notice the tackling dummy that is strung on a clothes line. Some of the team members are wearing turtlenecks while others are sporting the old-fashioned mouth guards.

ALL-STARS, MARCH 24, 2004. These seniors still had their uniforms in March because they were about to play in the National All-Star Game. They are, from left to right, Steve Ochap, linebacker; Pat Crossey, tight end; Mike Mills, defensive end; Paul Barsotti, kicker; and Mark Diffendal, offensive tackle. The football team won the PAC Championship in 1965, 1966, 1975, and 1980.

A Catch, 1967. This acrobatic catch happened behind Alumni Field House. The 1966–1967 football team had a record of 6–0–1. The Bethany College all-time record for most receptions is 70 by Denny Williams in 1980. The all-time record for receiving yards is 1,036, also by Denny Williams in 1980. The single-game record for most receptions is 11 and is held by Harold McKinley, vs. Gannon, on October 23, 1993.

"The Catch," Fall 1980. This is Bethany's famous "Hail Mary" pass in a game against Carnegie Mellon University. This amazing photograph shows Bethany losing 13–9 with five seconds left on the clock. The snapshot captures the exact moment when No. 88, Dale Grosso, snatches a pass from No. 12 Jeff Beers and is about to win the game on the final play—notice how the elated Bethany crowd is reacting. During the after-game celebration at Bubba's, bartender Chuck Kern served 152 upside-down kamikazes while Bubba gave the players champagne. (Courtesy of Bubba Reid.)

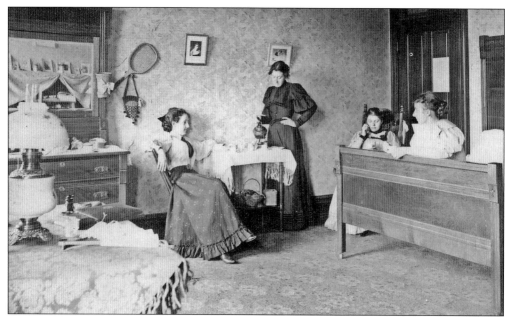

DORM LIFE GIRLS, 1894–1895. These girls from Phillips Hall are, from left to right, Bertha White, Margaret Jobes, Margaret Appleton, and Eda Morris. Notice the tea kettle, long dresses, gas lamp, and tennis racket in the photograph.

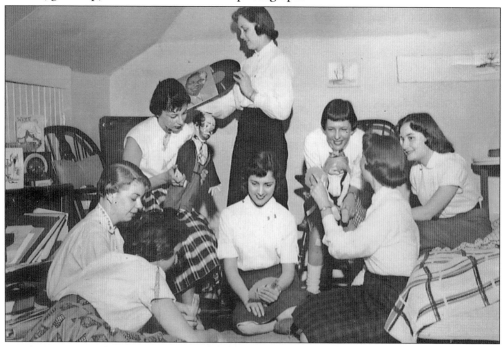

KAPPA DELTA, 1958. The Sigma Xi Chapter of Kappa Delta was founded on March 3, 1923, and they relinquished their charter in May 2002. The girls are listening to a Nat King Cole record in their sorority house. That year the girls of Kappa Delta, under the leadership of Carol Bush, won the Homecoming Float Award. Two KD sisters, Julie Watson and Barbara Fiers, were on the homecoming court. Fourteen new pledges gave a slumber party that year.

126

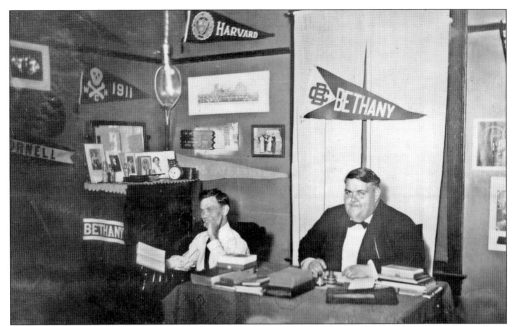

GUY'S DORM, 1917–1921. Pictured here are Mr. ? Thomas (left) and Mr. ? Moore. The photograph says that Mr. Moore weighed 350 pounds. Notice the Harvard banner and the bizarre skull and crossbones banner on the wall. One of the boys has a picture of his sweetheart on the dresser. (Courtesy of the scrapbook of Harry Ernest Martin.)

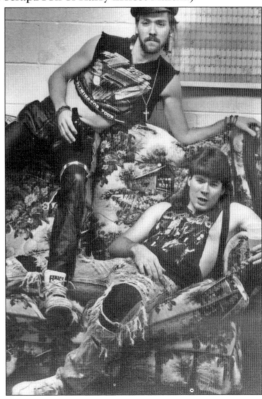

ROCK N' ROLL, 1991–1992. Senior Jim Noble and sophomore Brian Whitehill are dressed in heavy metal gear for a 1980s party. The guys were in the Kappa Alpha fraternity. (Courtesy of Steve Schenk.)

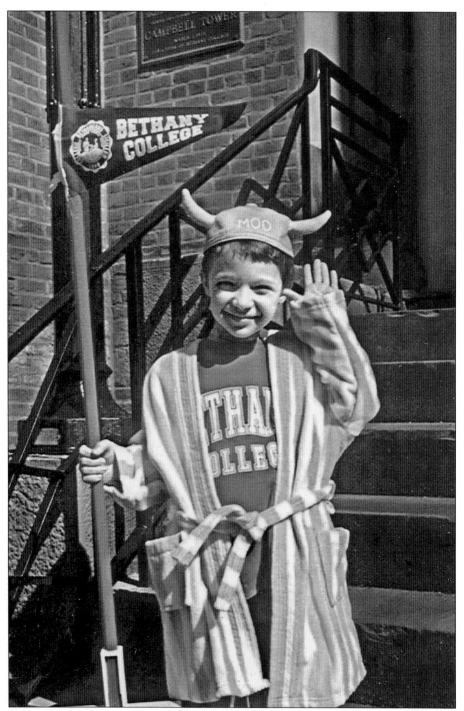

CLASS OF 2021?, MARCH 28, 2004. A young Rudy "Roo Roo" Agras is paying respect to the Moo Moo Moo with his requisite bathrobe and Moo antler gesture. He is wearing the same beanie that Perry Gresham sported when he was granted honorary membership in Moo Moo Moo. Whether Rudy will attend Bethany is tough to say as his grandfather is the chairman of Triangle Tech in Pittsburgh. But on this day he definitely had the Bethany spirit.